THE
Archive Photographs
SERIES

TRURO

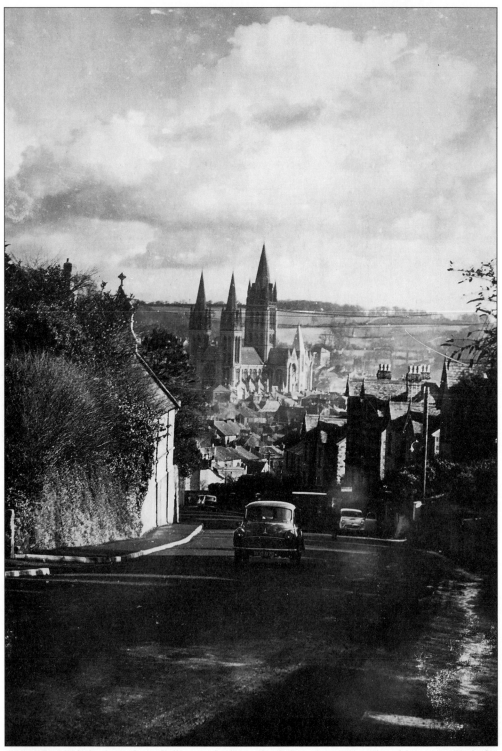

CHAPEL HILL looking down hill towards the cathedral in the 1950s. The old Roman Catholic church can be seen on the left.

THE
Archive Photographs
SERIES

TRURO

Compiled by
Christine Parnell

CHALFORD

First published 1997
Copyright © Christine Parnell, 1997

The Chalford Publishing Company
St Mary's Mill, Chalford,
Stroud, Gloucestershire, GL6 8NX

ISBN 0 7524 1026 1

Typesetting and origination by
The Chalford Publishing Company
Printed in Great Britain by
Bailey Print, Dursley, Gloucestershire

To my husband Peter, without whose help and support I could easily have become overwhelmed by photographs and not emerged for several years!

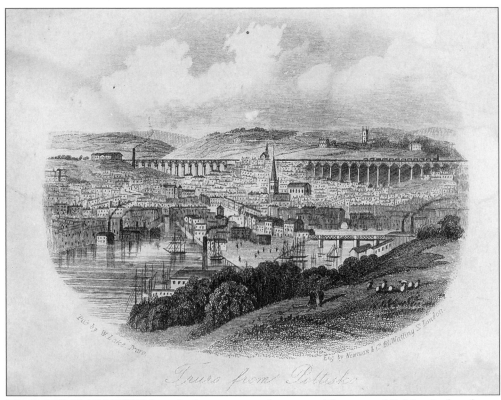

TRURO FROM POLTISCO in the late nineteenth century. The spire of St Mary's church can be seen clearly, with Kenwyn church beyond the old wooden viaduct. Plumes of smoke pour from the chimneys of smelting works at Carvedras and Malpas Road.

Contents

Acknowledgements

I would like to express my sincere thanks to all those who have lent me photographs and given me information to help compile this book, including: Pat and John Allam, Mrs Barter, Ken and Jean Collins, Margaret Davis, Mike Edwards, Fred and Flo Endean, Owen Endean, Mrs English, Don Gallie, Ronald Grubb, Dorothy Gundry, Philip Hills, Barbara James (Ledger), John James, Dennis Lamerton, A.J. Lyne, Robert Mallett, Margaret and Byryn Mitchell, Jacqueline Nancarrow, Mrs J. Nicholls, Miss O'Flynn, Elizabeth O'Neill, Neville Paddy, David Parnell, Peter Parnell, Mrs Penna, Elaine Thomas, Kay and Orchid Thomas, Linda Thomas, Marjorie Toy, J.H. Tregunna, Mary Truran of W.J. Roberts, Simon Vage, June Worgan, Kingsley Wright and Iris Wyatt.

I have made every effort to mention everyone who has contributed, if I have inadvertantly overlooked anybody, please accept my deepest apologies.

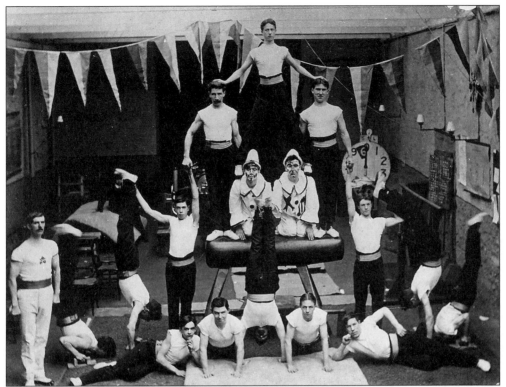

THE GYMNASTICS CLUB with members of the club performing an acrobatic routine. This was thought to be based at the People's Palace in the 1920s. Fred Brewer of H.D. Brewer & Sons, is second from the right in the front row, with his hands on the mat.

Introduction

I have always been interested in the history of Truro and when I was asked, out of the blue, to compile a book using archive photographs I could hardly believe my luck. Having established the fact that many of the existing old photographs had already been published and it would be necessary to search out something a little bit different I was thoroughly hooked.

It was thanks to the editor of *The West Briton* who published a letter from me and to Mrs Jo Elsome-Jones for taking up the theme and making it known in other publications that I was looking for material, which might otherwise never see the light of day outside its owners' albums, offers of photographs and postcards came rolling in. I also traipsed around Truro visiting all the old

established firms to enquire whether they had any archive material I could use.

All in all I met so many pleasant, obliging people that, although latterly Truro has become one of the 'in' places for people from up-country to settle, I know that there is still a nucleus of local people who 'belong' here and like me have a special feeling for Truro.

I have thoroughly enjoyed compiling this book, I can only hope that it gives as much pleasure to those who read it.

Christine Parnell,
Truro, April 1997.

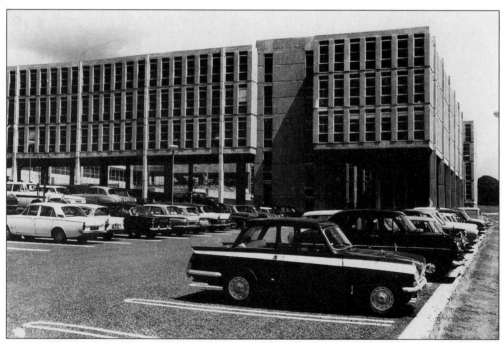

THE NEW COUNTY HALL. Typical cars of the period are parked outside the brand new county hall, which was completed in 1966.

One
Streets and Shops

Truro is undoubtedly one of the most attractive cities in Britain. Since Middle Row was pulled down and left Boscawen Street wider than the average street, the town centre has had an open, airy appearance. Georgian Lemon Street adds elegance, the rivers and bridges give an added character and yet the city has a homely feeling as the town clusters round the cathedral which was built on the site of St Mary's church. Over the years shops have come and gone and some beautiful buildings have been lost, this chapter shows just some of the changes that have taken place.

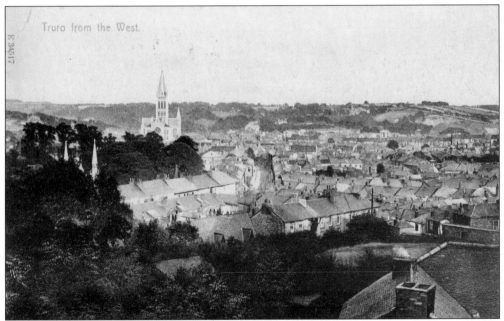

Truro from the West.

E 34517

TRURO FROM THE WEST in a photograph taken just after the turn of the century, which shows the cathedral with only one tower. The twin western towers were completed by June 1910 when a special service was held to celebrate the occasion.

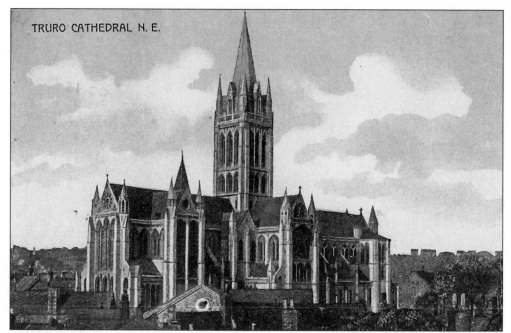

TRURO CATHEDRAL N. E.

THE CATHEDRAL in a closer view after the Victoria tower was built and before building work on the western towers was started.

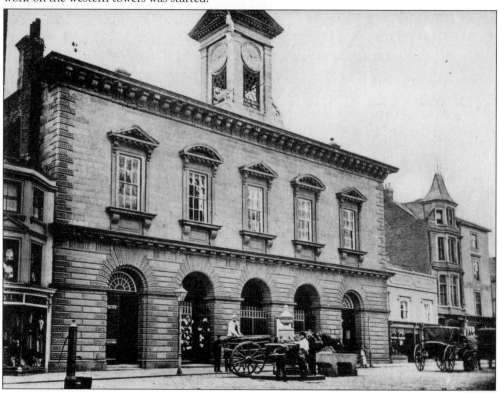

THE MUNICIPAL BUILDING in 1904. The fountain has long since been removed to Victoria Gardens and the pump is now found in the cemetery in St Clements Hill.

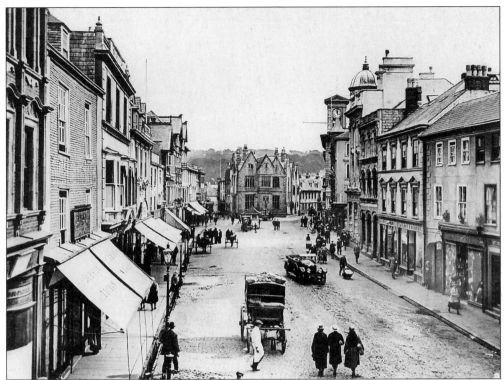

BOSCAWEN STREET. Both motorised and horse-drawn vehicles drive through the street before 1914. With it being a sunny day, shop blinds protect the windows of Pearson's, the jewellers.

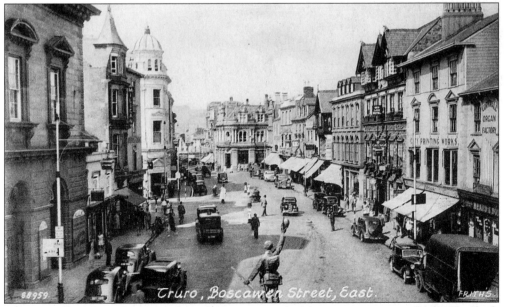

BOSCAWEN STREET. A view from the opposite end of the street sometime after 1922, which was when the war memorial was erected. The organ factory is on the right next to the City Printing Works and on the left a sign can be seen clearly advertising Milican the bakers.

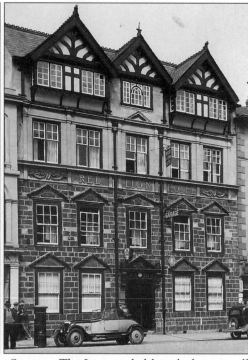

Left: TIPPET'S BACKLET. This led from River Street to The Leats and although the ope still exists today, the row of old cottages lit by the gas lamp has disappeared and the lane has lost much of its charm. Right: THE RED LION, *c.* 1940. This lovely old building was built in 1671 as the family home of the Footes before becoming an inn in 1769.

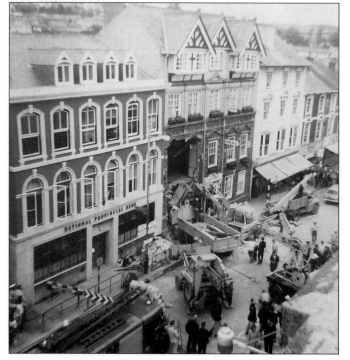

AN END OF AN ERA. In July 1967 it was a sad day for Truro when a runaway lorry careered down Lemon Street and ploughed into the beautiful Red Lion. As a result of this accident the hotel was demolished and replaced by a supermarket. This view was captured from the roof of Lloyds Bank by an alert Fred Endean.

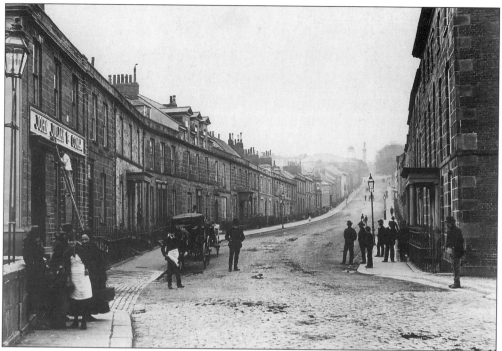

LEMON STREET, *c.* 1890. One of the finest Georgian streets in the country which looks much the same today but without the granite setts.

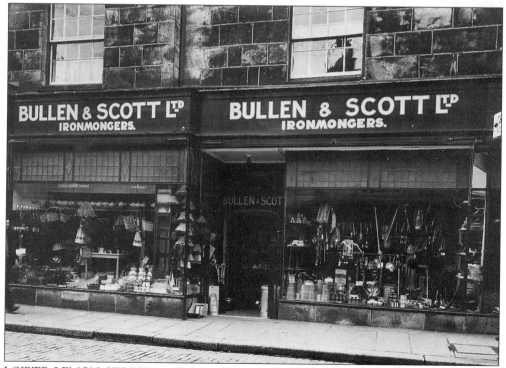

LOWER LEMON STREET. Bullen and Scott whose window display of ironmongery is seen here, have now disappeared and the shop has changed hands many times.

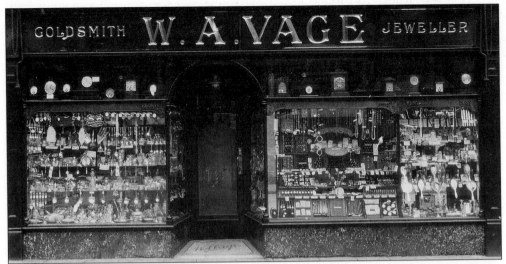

VAGE THE JEWELLERS, situated at the junction of St Mary's Street and New Bridge Street. In 1913 Mr William Vage purchased the shop that he had previously rented. The day after the purchase he closed and had a new shop front built, as shown in this photograph, which remains the same today.

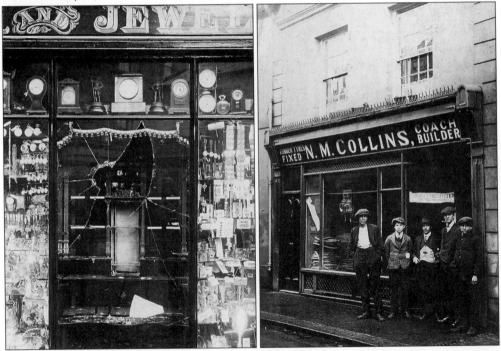

Left: SMASH AND GRAB, the window of W.A. Vage after the raid in 1911. Two tramps were arrested after Mr Vage donned his silk hat and tail coat and gave chase. Later, during the Great War, Mr Vage's nephew fell into conversation in the trenches and found he was talking to one of the felons responsible for the smash and grab. Right: NO. 108A KENWYN STREET, c. 1925. Mr Collins can be seen in the centre flanked by his staff. The tyres in the window are for traps and jingles. By the mid 1930s Mr Collins had moved to Bodmin to live and the shop was occupied by Miss Osborne with her grocery business.

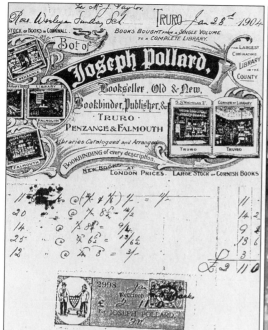

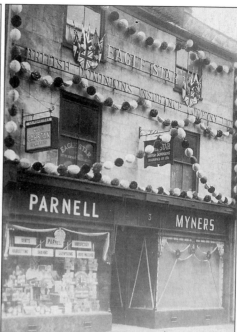

Left: BILL HEAD. Mr Pollard opened three book shops in 1890 and traded until his early death in 1915. His son, Edgar, who was trained in the business, died in the same year causing the closure of the shops. The Truro branch was at No.5, St Nicholas Street. Many old books still have Pollard stickers inside today. Right: LOWER LEMON STREET. Jack Parnell, gentlemens hairdresser, alongside Myners, the butchers, seen here decorated for the coronation of King George VI in 1937. Until very recently the site was occupied by Mr Christopher's Cafe.

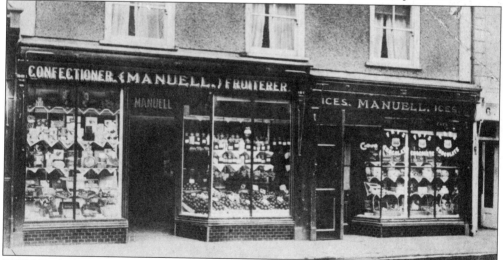

THE ICE CREAM PARLOUR. In 1905 Anne Manuell opened a fruit and confectionery shop in King Street, which also sold pasties for the men working on the cathedral. These she made herself and they were extremely popular. Later, with her sisters Edith and Susan, she bought the tailors' shop next door. They started to make ice cream and had ice sent daily from Plymouth until P.H. Tonkin opened an ice-making plant in Truro. The site is now occupied by Trim the greengrocers.

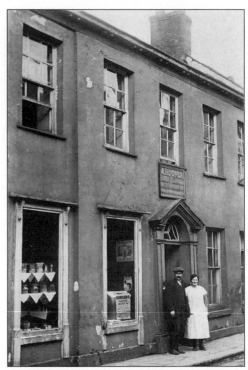

Left: WOODEN SETTS, *c.* 1940. St Mary's Street is paved with wooden setts which are now covered in tarmac. When the setts were wet they were extremely slippery. Today they may still be glimpsed close to the kerb. Right: FAMILY PLUMBERS. Mr Arthur Hooper stands with his daughter outside his shop in New Bridge Street in 1913.

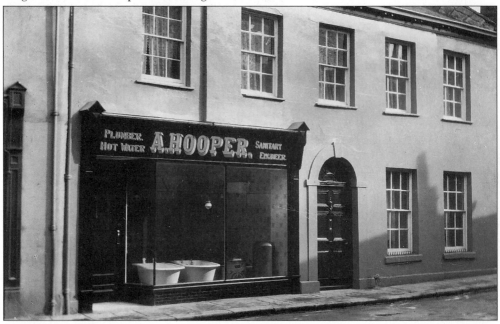

FACE LIFT. Mr Hooper's new shop, in the same place from 1930 to 1935, proudly displays the latest bathroom furniture.

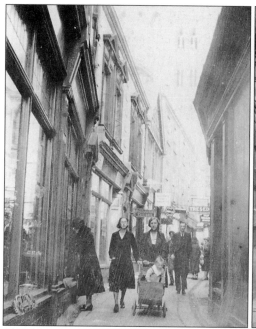
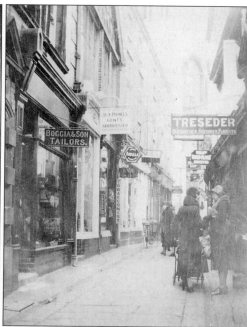

CATHEDRAL LANE, c. 1939. Once known as Street Edy or Church Lane, this little ope is known today as Cathedral Lane. The left view shows shoppers approaching Boscawen Street from St Mary's Street. The view on the right clearly shows some shop signs: Boggia & Son, tailors; Jack Parnell, gentlemens hairdresser and Treseder, nurserymen, seedsmen and florists.

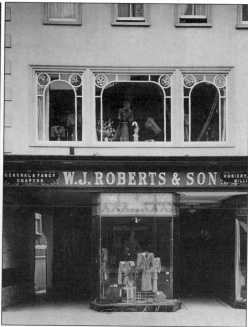

Left: CHANGING TIMES, a more recent picture of Cathedral Lane which has changed little except that shopkeepers come and go. Right: ROBERTS THE DRAPERS. The shopfront in 1930 with the beautiful window above displaying dresses and millinery. On the left the original entrance to the ope linking Boscawen Street with Lemon Street can be seen.

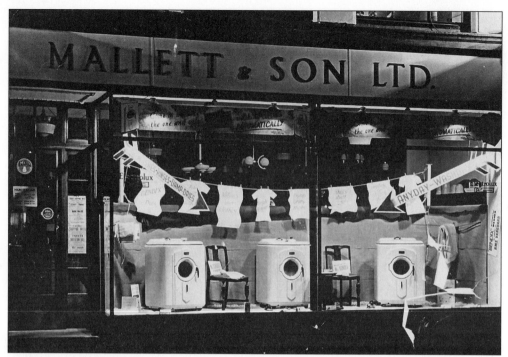

ANY DAY WASHDAY. The very latest in Bendix washing machines are displayed in the window of Mallet & Son in 1939.

PYDAR STREET, now Ottaker's bookshop, much of the fascia of this building was retained when it was rebuilt in this decade.

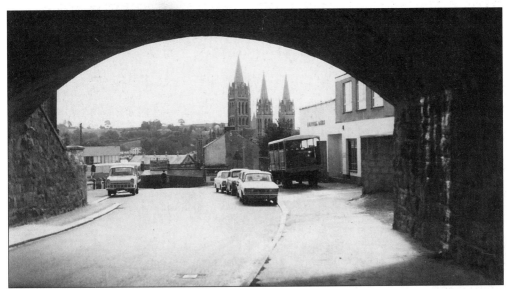

UNDERNEATH THE ARCHES. The railway arch at the top of Pydar Street neatly frames the cathedral and Holywell Dairy. Almost everything in the picture except the cathedral has now greatly changed.

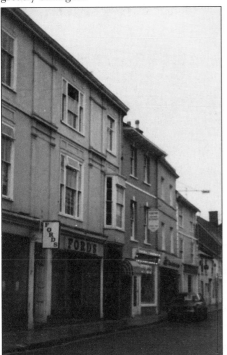

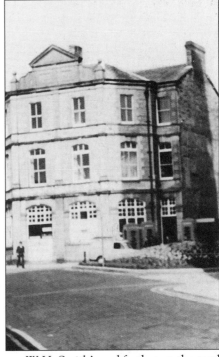

Left: PYDAR STREET, *c.* 1960. Ford's music shop is now W.H. Smith's and further up the road what were once private houses are now shops in a pedestrianised area. Right: THE MAIN POST OFFICE, *c.* 1974. A Sylvanus Trevail building, the post office occupied the corner of Pydar Street and High Cross. It has since been demolished and replaced by Marks & Spencers. Gone are the old red telephone boxes and little red vans moving in and out of the yard behind the building.

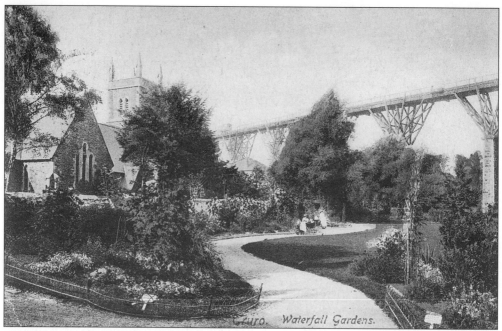

WATERFALL GARDENS. This photograph was taken before 1904 when Brunel's wooden viaduct was replaced by today's granite structure. Across the road is the church of St George the Martyr.

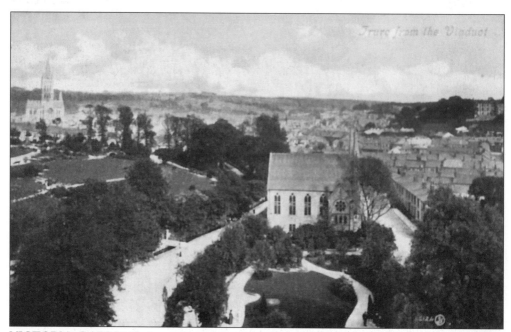

VICTORIA GARDENS, in a view taken from the viaduct in 1905. St George's Methodist church was designed by Walter Chalmers Smith (1824 -1908) who was also the author of the hymn *Immortal, Invisible, God Only Wise*. He was a member of the Smith family of Criddle & Smith, a well-known Truro firm. On the left is the cathedral with only its central tower and on the right is the Royal Cornwall Infirmary.

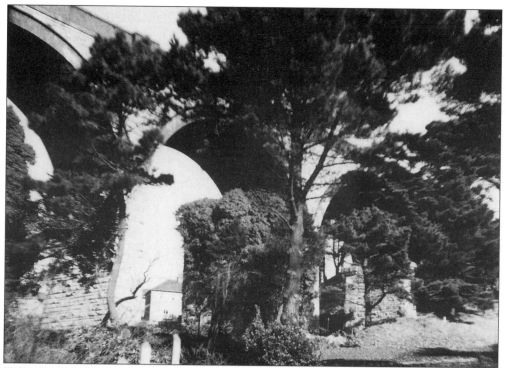

THE VIADUCT, 1950. The new stone structure dominates the ivy clad stumps of Brunel's original viaduct. The new viaduct was completed in 1904 but the disued pillars still stand today as an echo of the past.

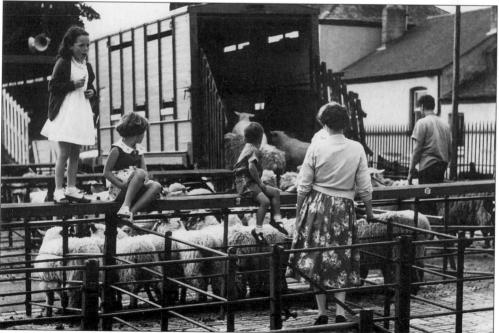

LOADING SHEEP, c. 1960. The old cattle market, now the site of the new Crown Court building. At one time there was a railway halt here at the end of Claremont Terrace.

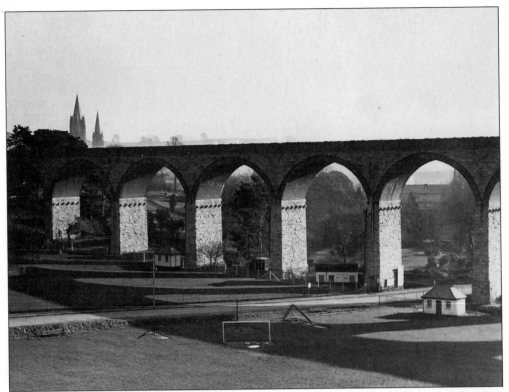

DREADNOUGHT PLAYING FIELDS. Looking towards Victoria Gardens the fountain removed from Boscawen Street can be seen through the arch beyond the girls toilet block. The boys lavatory is on the right and both have been demolished but a new building has replaced the girls toilet.

THE NEW COUNCIL HOUSES, at Hendra in the 1930s. The houses face the viaduct across the Dreadnought playing fields.

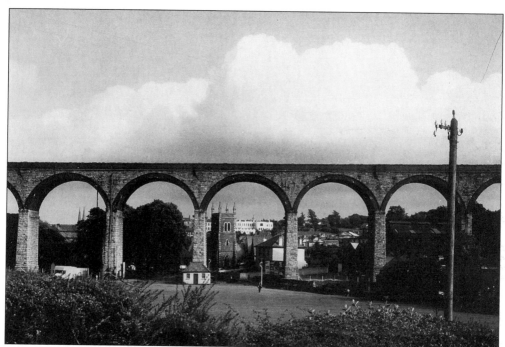

CHURCH OF ST GEORGE THE MARTYR. The church is seen in the top picture with the Royal Cornwall Hospital behind and Lander's monument just showing beyond that. On the right are buildings on the site of Carvedras smelting works and on the left two spires of St George's Methodist church now closed for worship. In the photograph below, St George's church showing the bridge over the River Kenwyn and the entrance to The Leats can be seen.

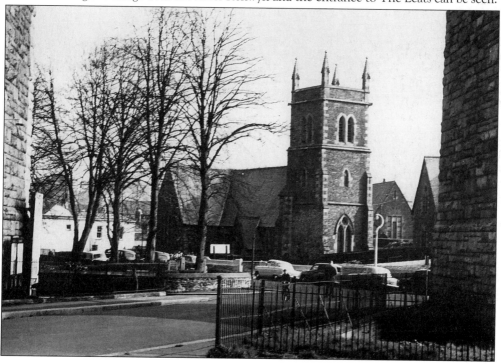

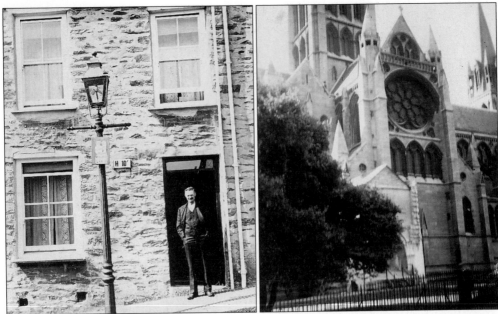

Left: EDWARD STREET, *c.* 1930. Retired postman Clear Parnell stands outside his house at No.10. Together with No.11 and like so many of the Edward Street houses this is now a solicitor's office. These changes were brought about by the arrival of the Crown Court. Right: RAILINGS, 1935. Bordering the cathedral, these railings were removed for the war effort along with most of those from Truro, like the railings from Lemon Street and Dreadnought playing fields.

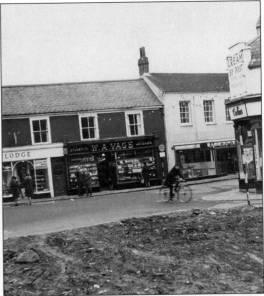

Left: NEWHAM INDUSTRIAL SITE, *c.* 1960. This warehouse is the only building to survive development in the eighties and nineties and remains to remind us of how things used to be. Right: PROGRESS? This is a gap at the junction of Quay Street and Duke Street in about 1965, when Treleavens Bakery was pulled down to make way for development. This was part of the old coinagehall site and today the ugly 1960s building which took its place stands empty.

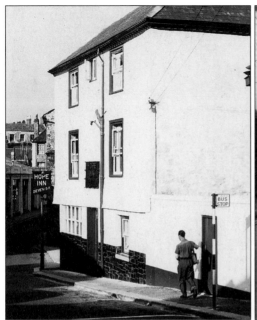
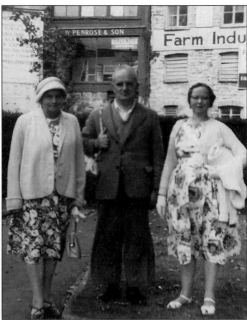

THE HOPE INN. This pub was at the bottom of Mitchell Hill but was demolished in the 1960s to allow the widening of St Austell Street. (see Chapter 3 p51). Right: PENROSE & SON. Family members stand outside the rear of Penrose & Son, in Malpas Road, during the 1950s. On the left is Mrs Meeta Repper, granddaughter of William Penrose the founder of the firm. She is with her cousin, Mr Gerard Penrose (an organ builder in Sheffield, Yorks) and his wife, Ivy.

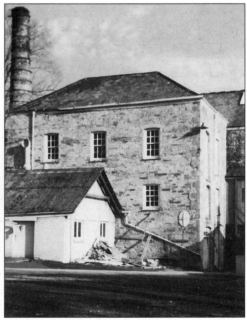

Left: PYDAR STREET. The Williams almshouses, now demolished, stood on the site which is now occupied by the Carrick District Council offices. Right: THE TRURO STEAM LAUNDRY. The laundry stood opposite the Drill Hall in Moresk Road, a block of flats now occupies the site.

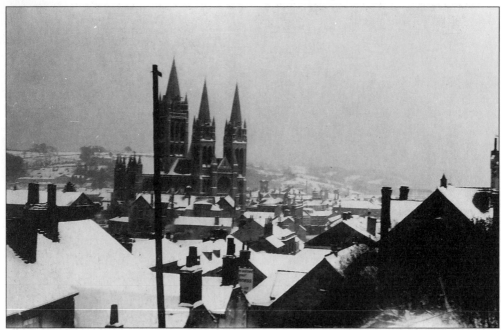

THE 1947 BLIZZARD. The snow-covered roofs belong to St Mary's junior and infant school in Pydar Street. The picture was taken from the back garden of Mr Don Gallie's house in Castle Hill.

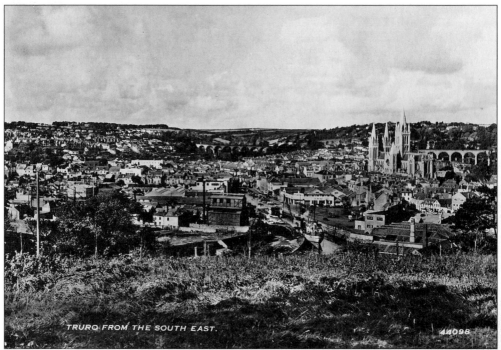

TRURO FROM POLTISCO, *c.* 1950. Sixty years later than the view shown on page one, a ship is docked next to the gasworks. The chimneys of the Malpas Road smelting works are on the right and part of the river has been covered over to form Lemon Quay car park.

26

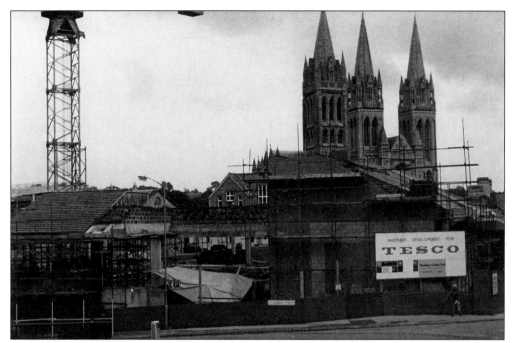

ARRIVAL OF TESCO. During the 1960s, major development took place in Pydar Street at its junction with Moresk Road. Tesco have now moved to Garras Wharf and C & A now occupies this site.

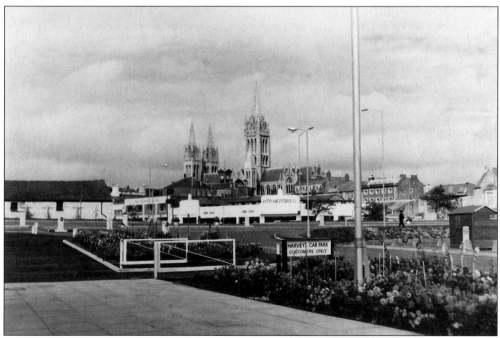

HTP MOTORS, 1960. For many years Hosken, Trevithick and Polkinghorne's garage was a feature on Back Quay at the junction with Green Street. It is now an indoor market with new shops along the front. Harvey's beautiful flower beds have gone to make way for a wider road and roundabout. Harvey's too have been swallowed up and Curry's have a superstore on its site.

NO.6 KING STREET. These were the premises of H.D. Brewer & Sons in 1935. They were grocers and tea blenders who traded until 1955. H.D. Brewer had taken over the shop from his father-in-law, J.C. Juleff, at the turn of the century. It was next door to Manuell's ice cream parlour. For many years No.6 was Miller's, the estate agents, but the building is vacant at the time of writing.

Two
The River

The Rivers Kenwyn and Allen flow through Truro and become the Truro River as it forms the upper reaches of the Fal. Until the 1930s larger ships would come up into the town and moor at Back Quay or Lemon Quay, an area that now forms a car park. The dredger no longer clears out the silt and larger boats can no longer come right up the river. However the river has played an important part in the development of the town and many people would like to see it have a more prominent role today.

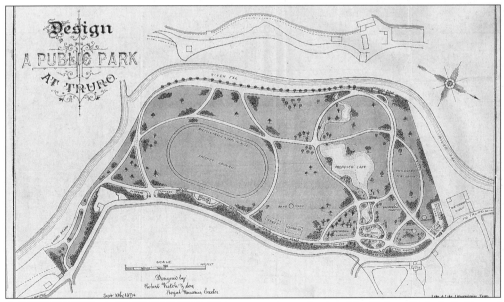

A DESIGN FOR A PUBLIC PARK. This was a plan submitted by Robert Veitch & Son of Exeter for Boscawen Park. It was not selected but if it had been, perhaps the system of ponds and lakes might have prevented the flooding which has afflicted Trennick Mill for so many years.

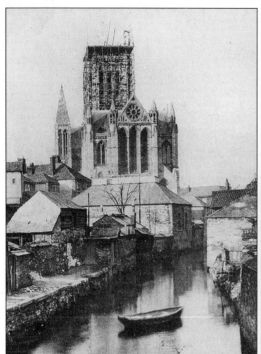
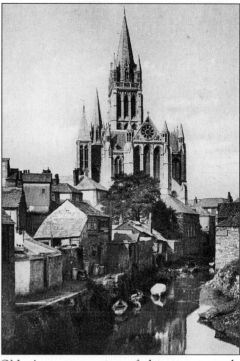

THE CATHEDRAL UNDER CONSTRUCTION. A common view of the river is made unusual by the scaffolding and the partially built Victoria tower. The largest of the towers was built before the two western ones which were added by 1910. Right: THE CATHEDRAL FROM THE EAST, c. 1920. This is the most common view of the river and the cathedral taken from New Bridge looking towards Old Bridge.

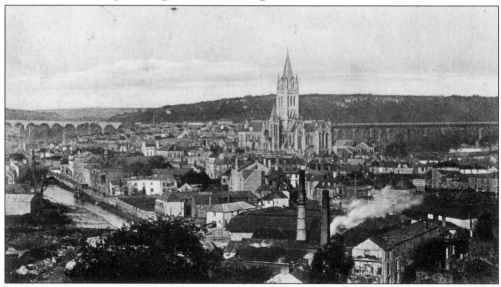

THE VIADUCTS OLD AND NEW, c. 1900. Brunel's wooden viaduct can be seen on the right but on the left the new stone viaduct is in place. The Malpas Road smelting works are in the foreground and the river is open between Lemon and Back Quays with Lemon Bridge spanning the water at Lemon Street.

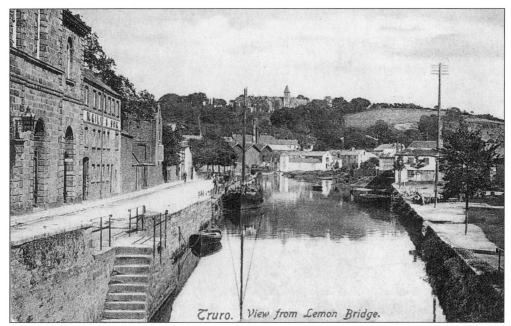

Truro. | View from Lemon Bridge.

THE RIVER FROM LEMON BRIDGE, *c.* 1910. Lemon Quay is on the right and Back Quay on the left with the rear entrance to the municipal buildings. N. Gill and Son are occupying the site where F.W. Woolworth now trade.

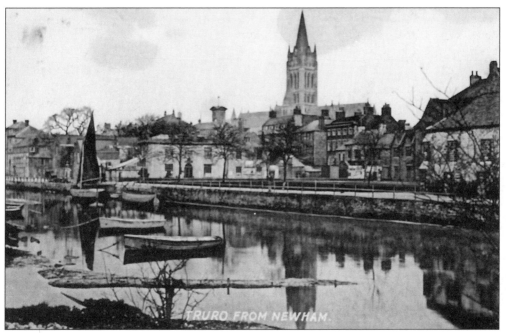

TRURO FROM NEWHAM.

TRURO FROM NEWHAM, *c.* 1920. The town clock is easily visible and across The Green (formerly a bowling green) is the rear of the building which has been the Fighting Cocks Inn, birthplace of Richard Lander and later the Dolphin Buttery. The dolphin from the wall of the Buttery is preserved at Boscawen Park.

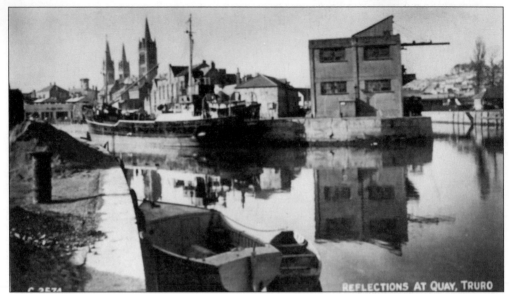

A SHIP DOCKED AT GARRAS WHARF, *c.* 1920. Worth's Quay with its pavilion is on the far right. The huge warehouse has long since been demolished.

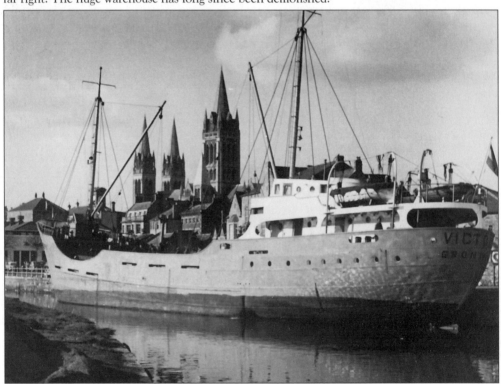

VICTORY, *c.* 1950. Even as late as the 1960s ships were able to navigate the river right into the city. The rattle of the dredger, keeping the channel open for larger boats such as *Victory*, was a constant background noise. For many people the rattling dredger and the delicious smells of humbugs or gingerbreads from Furniss's factory formed a permanent memory of childhood in Truro.

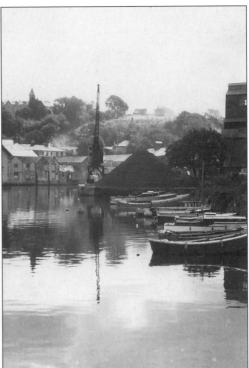

Left: BOSCAWEN BRIDGE, *c.* 1960. This is the second bridge opened in 1862 and used until the 1960s when the Morlaix Avenue bypass was built. Behind, the building which has been at different times the premises for Penrose, sailmakers and also Hicks' garage can be seen. The bridge was used as a diving board by many local children during the summer months. Right: THE RIVER, 1950. Truro School is visible on the skyline and the gasworks, since demolished, on the right.

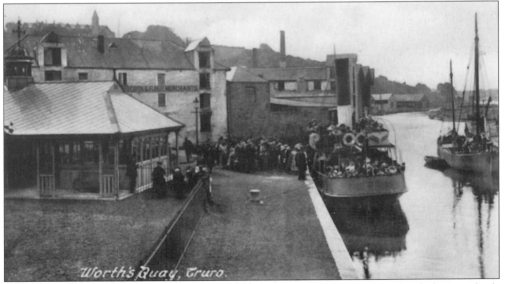

WORTH'S QUAY. The *Princess Victoria* leaving the quay in about 1920. The shelter was built in 1911 and the *Princess Victoria* ceased to operate after the outbreak of the Second World War.

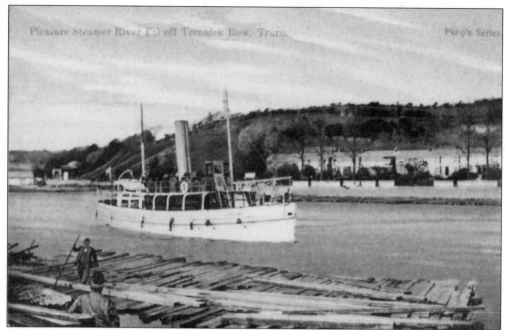

VICTORIA. Logs awaiting attention from Harvey and Company float in the river as *Victoria* steams past. The little row of houses in the background is Trennick Row.

Truro, Boscawen Park and River

BOSCAWEN PARK, 1900. The river winds past the park, which has more trees and less flower beds than today. The tea rooms, locally known as the Junket House overlook the pool which today is a haven for wildlife.

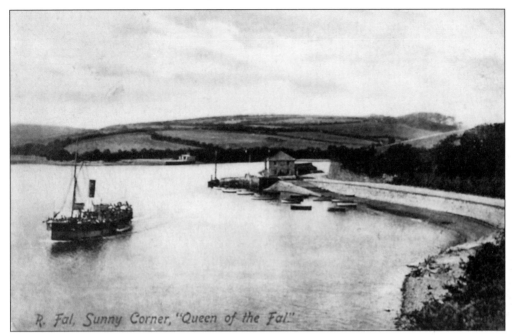

QUEEN OF THE FAL, *c*. 1905. A heavily laden pleasure steamer glides past Sunny Corner on her way to Falmouth.

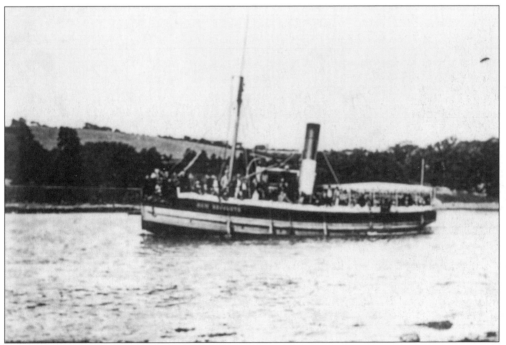

THE NEW RESOLUTE. Another very popular pleasure steamer, *The New Resolute* ran trips from Malpas until the outbreak of the Second World War.

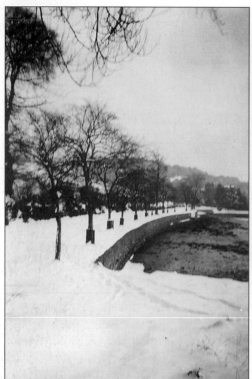

Left: MALPAS ROAD, FEBRUARY 1956. An unusual scene with Malpas Road under several inches of snow. Right: TRENNICK MILL, 1956. The Mill House or Junket House under a heavy covering of snow which makes it look more like a gingerbread house covered in icing.

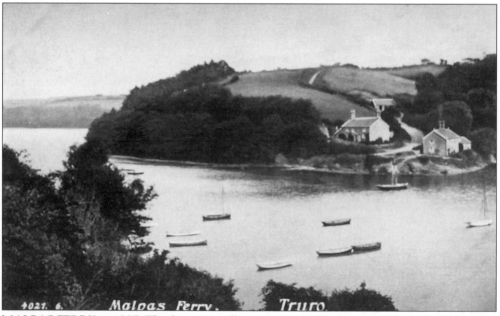

MALPAS FERRY, *c*. 1905. The ferry was still running in 1955 when Sam Martin known as the Mayor of Malpas rowed travellers to or from St Michael Penkivel.

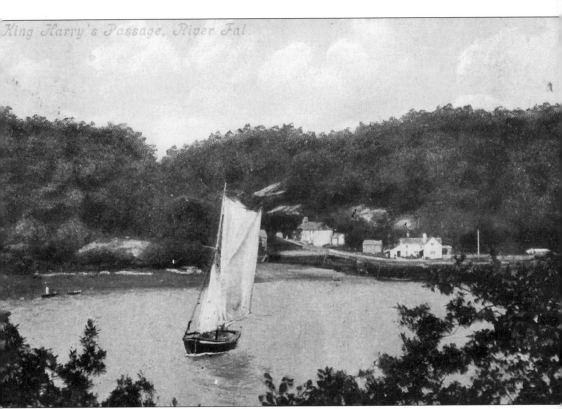

UNDER SAIL. A yacht peacefully sailing up the river at King Harry Passage.

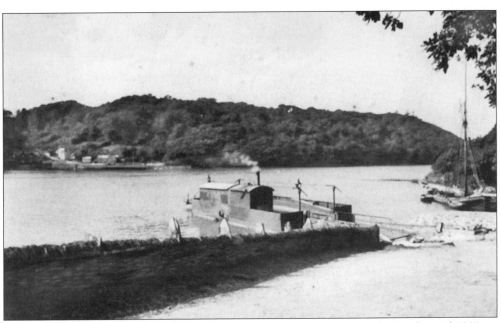

KING HARRY FERRY. The old steam ferry sits waiting for passengers during the mid 1930s.

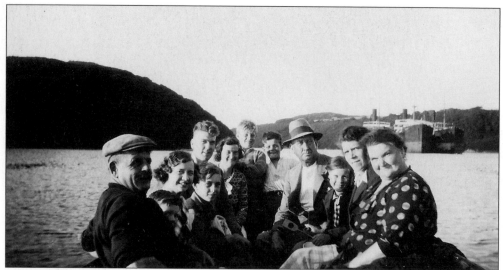

FAMILY OUTING, 1933. Mr Ernest Lamerton in his trilby hat enjoys a day out with his family at King Harry Passage. He was the landlord of the Dolphin Inn in Truro and his wife Annie is on the right at the front. Even in those days it was usual to see ships laid up in the Fal.

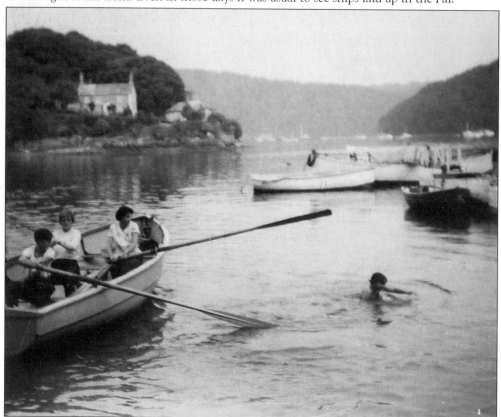

SEA RANGERS AT MALPAS, *c. 1960*. Skipper, Miss E. Coombe, later the Mayor of Truro, hoping her crew, Christine Mitchell and visiting sea scout Timothy Crocker, can manage to avoid a lone swimmer.

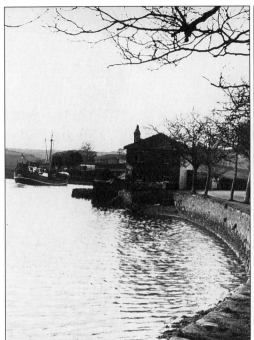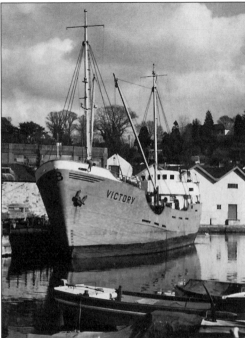

Left: SUNNY CORNER, 1955. A small coaster makes its way to Lighterage Quay past the spot where many Truro boys and girls learned to swim. Right: THE VICTORY AT TRURO, c. 1950. On the quay is a Tappers Lorry. They were fruit and vegetable wholesalers so perhaps the *Victory* had a cargo of exotic fruit from overseas.

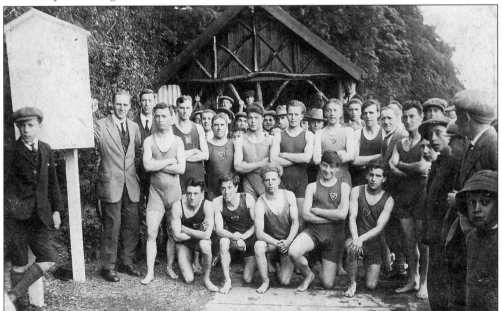

THE TRURO SWIMMING CLUB, c. 1920. Members of the club shown at Sunny Corner resplendent in their costumes include Mr Pearson (jeweller), second from left in the back row. The third swimmer from the left is A.P. Rowe and in there somewhere are Joe Bertolucci, E. Sweet, G. Oakes, Mr Roberts and Mr Lean.

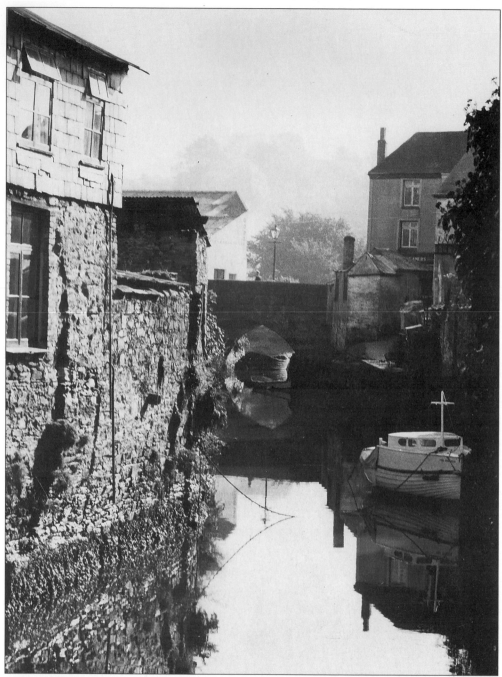

NEW BRIDGE FROM OLD BRIDGE, 1955. This is a much changed view today with River Walk going through the ope on the right to join New Bridge Street. Boats are no longer moored here but the iron rings to secure them can still be seen in the wall on the left. A regular sight in the 1950s was of Mr Peters, who owned chickens on Furniss's Island using his boat every day to tend his flock.

Three

People at Work

Truro was a stannary town and although the smelting works no longer exist many of the buildings are still in use for other purposes. The Furniss biscuit factory has gone and the cattle market has moved out to the edge of the town to make way for a new Crown Court. Consequently Truro seems to be full of solicitors, building societies and shop-keepers. Truro is the acknowledged shopping centre of Cornwall which is unfortunate for those other towns which do not have the chainstores clamouring to go there. This chapter shows a selection of businesses which used to be carried on in Truro before almost every town in the country of any size became a carbon copy of all the others.

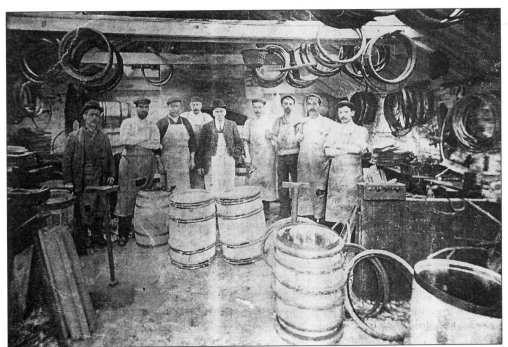

THE COOPER'S SHOP, *c.* 1910. Workers of W.W. Davey, coopers, pose in their workshop in Quay Street.

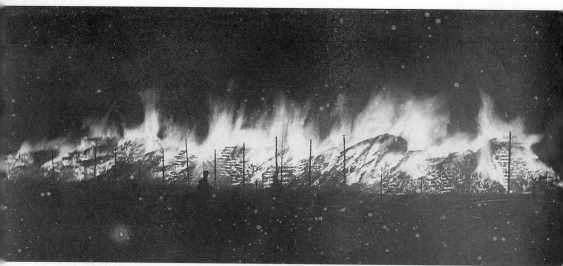

FIRE! On 16 November 1896 fire broke out in Harvey's timber yard in Newham. The top picture, taken at 7.00p.m., shows the fire taking hold and the bottom photograph, taken at 7.15p.m. shows the intense blaze with people standing by helpless.

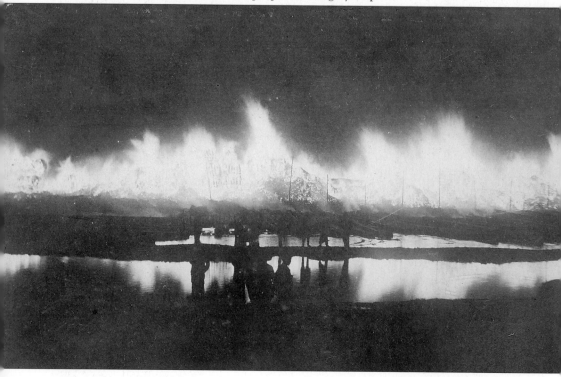

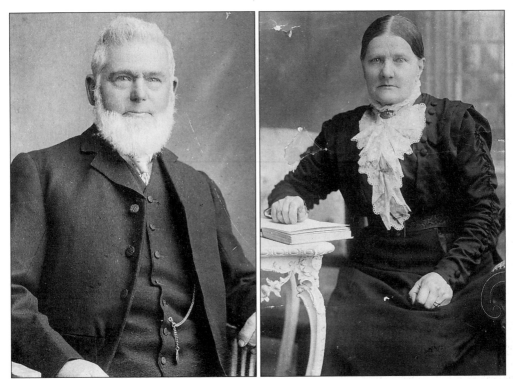

GOLDEN WEDDING. William and Susan Penrose of Trafalgar Row, Truro, pose for the camera in 1909 on the occasion of their golden wedding anniversary. Mr Penrose was the founder of Penrose and Son, sailmakers. His granddaughter is shown on page 25, standing in front of one of the company premises. Penrose and Son was famous for making the largest tent in the world although ownership of the firm was in other hands by that time.

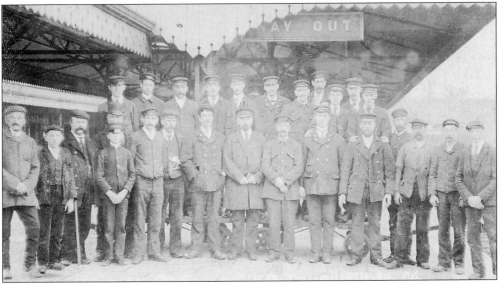

GREAT WESTERN RAILWAY. Some of the staff of Truro railway station group on the platform, 16 December 1904. The name Great Western has been restored recently but it is unlikely we will ever see this many staff at Truro station again.

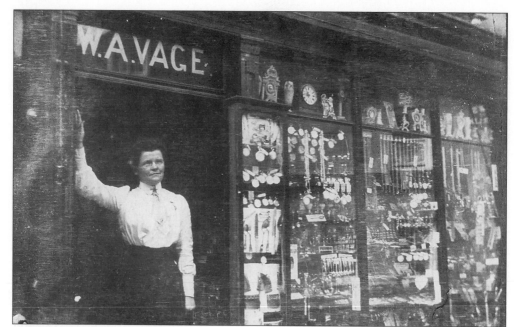

MISS MARY ELLEN VAGE, known as 'Nellie', she was the sister of William A. Vage the founder of the jewellers shop. She worked in the shop with him from 1903 and this photograph is prior to 1910 showing the old shop front which Mr Vage had replaced in 1913. Miss Vage died in 1911.

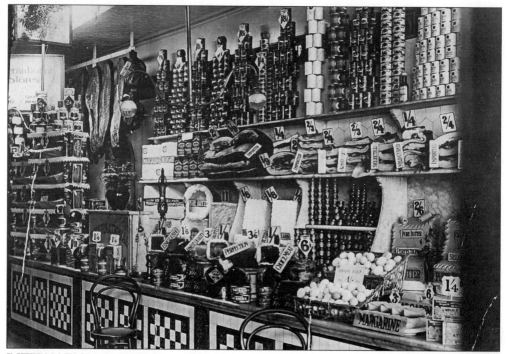

INTERNATIONAL STORES, c. 1930. This is a typical interior of the shop which had various locations in Truro at different times. Their last store was in Victoria Square, now occupied by Gateway.

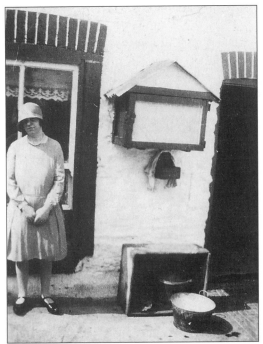
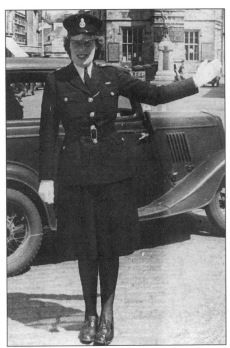

MAID OF ALL WORK. In the 1920s Ethel Marlow worked for Mrs Ethel Mitchell of No.23 Kenwyn Street. She is seen here standing in the backyard beside the meat safe (on the wall) and the slate slab housing the buckets. In later years the slate slab was broken and replaced by a piece of marble from an old washstand. Right: WPC NAN GRAY was the first woman police officer in Truro and is seen here on duty in Boscawen Street in about 1948.

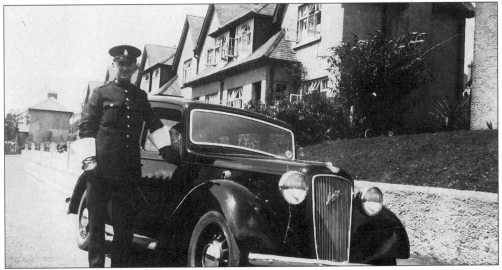

THE FIRST POLICE PATROL CAR IN TRURO, 1943. PC 57 Samuel John Oatey (not to be confused with PC Sam Oatey of Chacewater) of the Cornwall Constabulary captured outside the police house at No.2 Courtney Road, Hendra. Having previously been the driver for the Deputy Chief Constable he was entrusted with one of the force's first patrol cars. At this time he was also the Bomb Recognizance Officer, a duty for which the car was much more useful than the usual bicycle.

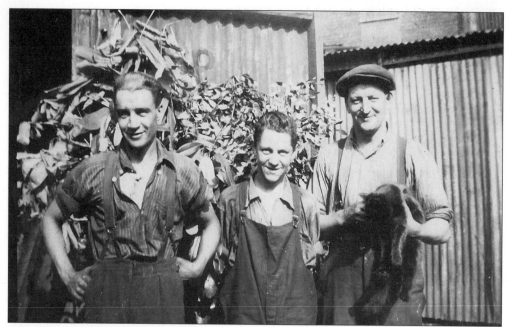

THE BLACKSMITHS SHOP. Fred Mitchell Snr (holding the cat) with sons Fred Jnr and Byryn in their shop at No.108 Kenwyn Street, 1936. Byryn had been about to leave school at 14 when his father needed an apprentice so his career was mapped out for him and not open for discussion.

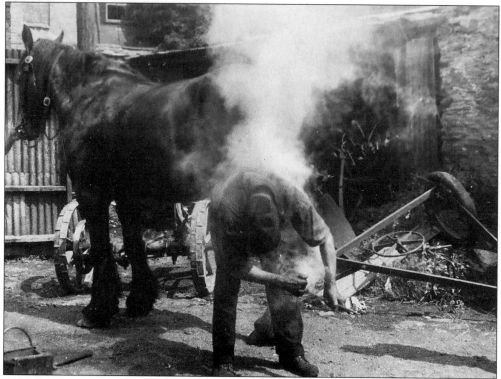

APPLYING A HOT SHOE. Fred Mitchell Snr, at work in his smithy in 1930.

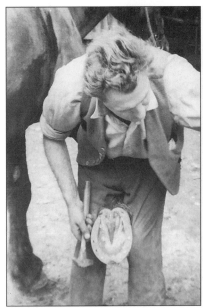
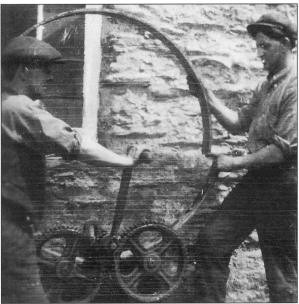

Left: LIKE FATHER, LIKE SON. Byryn Mitchell fitting a hot shoe during the 1950s.
Right: MAKING A BIND, or metal tyre for a horse-drawn cart during the 1930s. Fred Mitchell, on the right, is working with Mr Walters, who later became a cobbler.

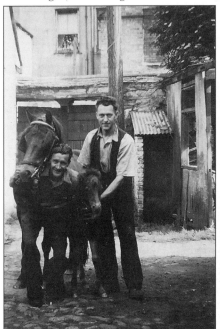
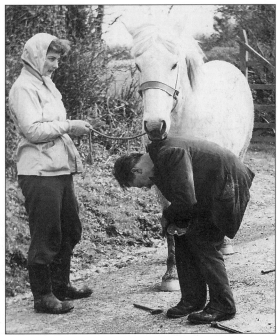

Left: BABY CAME TOO. A farmer found it impossible to get his mare to the smithy because she refused to leave her foal, the solution was to bring baby as well. Byryn Mitchell is holding the foal and Fred Jnr peeps out between the horses. The cobbles of the yard are clearly visible and have been there since they were laid down by the Dominican monks in the thirteenth century. Right: COLD SHOEING. A visit to Idless to cold shoe a horse for Miss Andrew during the 1950s. Most of the time taken for this operation was in catching the horse in the first place.

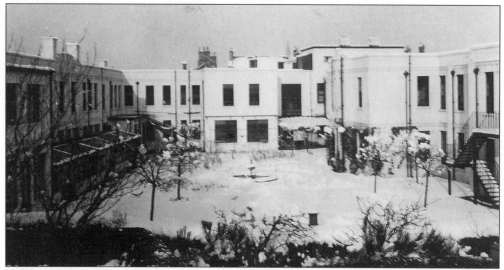

THE ROYAL CORNWALL INFIRMARY, 1956. The hospital is seen here under a blanket of snow. The balcony on the left was where TB patients were treated and it had tarpaulins to pull down over it in inclement weather.

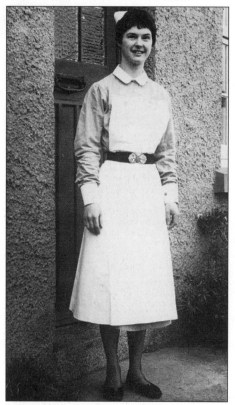

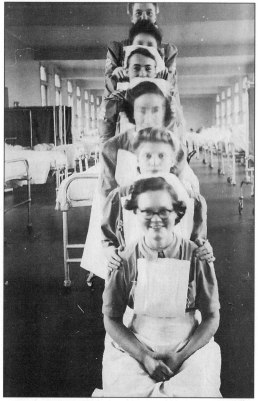

Left: THE NURSE'S UNIFORM, 1956. SRN Marjorie Parnell with her starched collar, cuffs and apron, very different from the uniform nurses wear today. Right: MALE SURGICAL WARD, 1947. The nurses are, from the top: Mayne, Laity, Cardell, Cleary, Gillard and Gundry. They make a cheerful totem pole, no doubt to the amusement of the ward's patients.

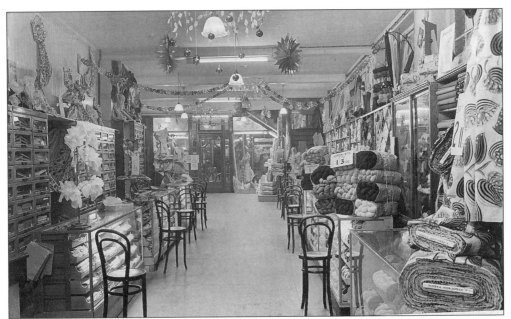

W.J. ROBERTS, 1951. This was the era when the floorwalker would greet customers at the door and direct them to the appropriate area of the shop. Chairs were placed about the store to allow the customers to sit and chose their purchases in comfort. The shop opened at 9a.m. but assistants who lived in town were expected to arrive 15 minutes early to dust the shelves. Those coming in from the country were excused this task.

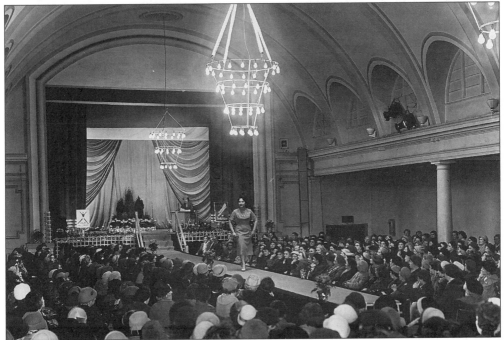

A FASHION PARADE, 1959. W.J. Roberts regularly staged fashion shows, usually in aid of a deserving charity. This one was held in the City Hall, which at the time of writing is undergoing a transformation into the Hall For Cornwall.

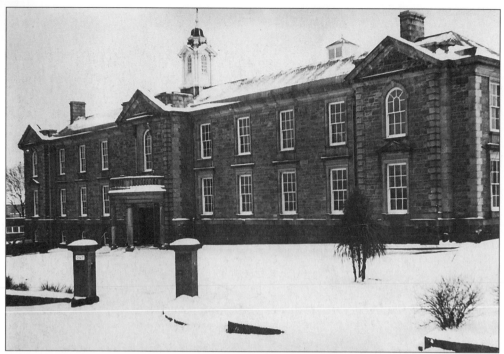

THE COUNTY HALL, long before the new county hall was built, this shows the building after a heavy snowfall during the night of 29 January1947.

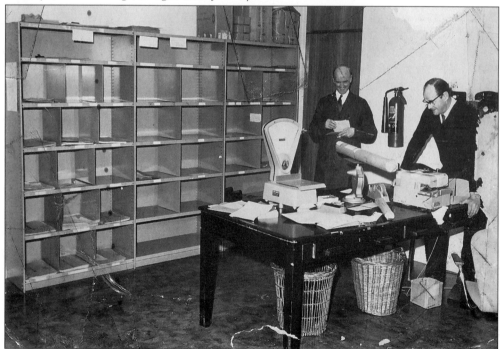

THE SORTING OFFICE, NEW COUNTY HALL. Jack Parnell and Albert Rapsey busy themselves in central despatch in 1968. The empty pigeon holes suggest they are waiting for a new influx of mail or are nearing five o'clock.

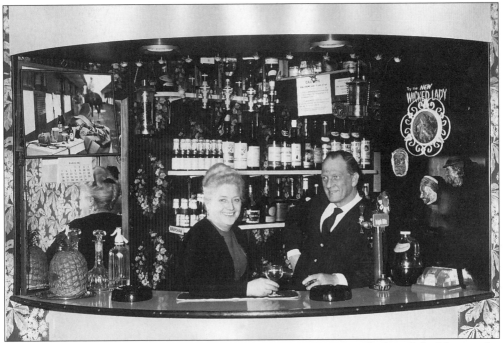

THE HOPE INN. Landlord Alan Allam and his wife Lil relaxing in the bar of the Hope at the bottom of Mitchell Hill. The pub was demolished in the early 1960s.

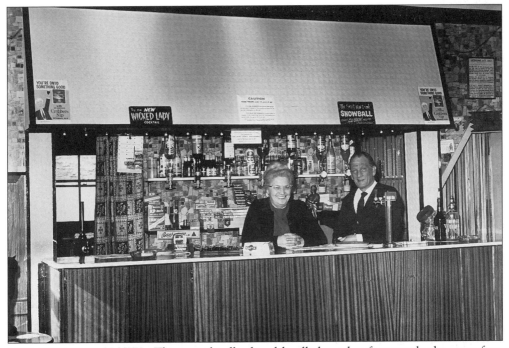

THE CENTRAL HOTEL. The same landlord and landlady and unfortunately the same fate. The Central Hotel was in Quay Street but was knocked down in the early 1980s and the site is now an open space used as a private car park.

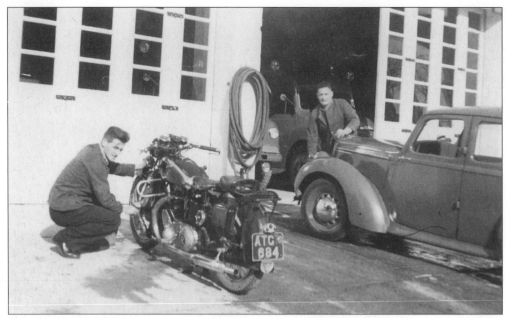

THE FIRE STATION, *c.* 1950. Eric Kerslake and friend busy on the station forecourt at St Georges Road, tending to their private transport during their dinner hour.

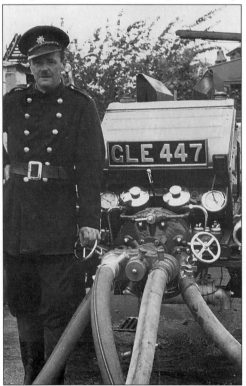

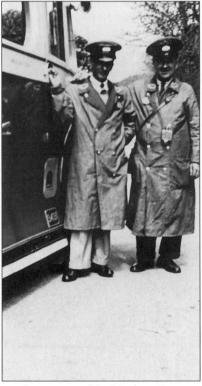

Left: A MOBILE PUMP. Pumping equipment in operation demonstrated by Leading Fireman Jack Parnell in 1958. Right: BUS CREW. The conductor, Mr John Paddy, is on the right and his driver stands beside their Western National bus just after the Second World War.

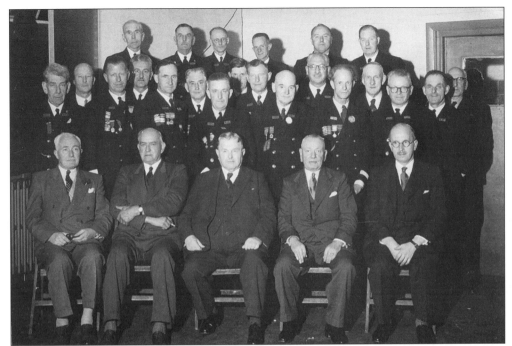

THE WESTERN NATIONAL OMNIBUS COMPANY, *c. 1960*. The staff attend a medal ceremony at the Womens Institute Hall. Truro's Mr Percy Chapman is standing third from the right.

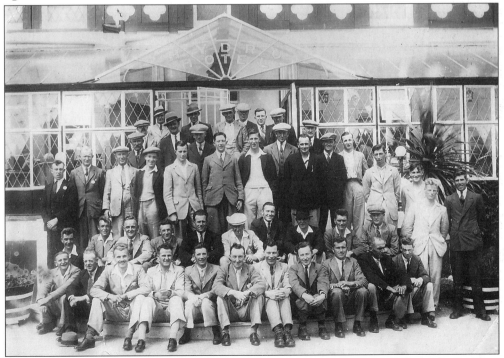

THE BUILDER'S HOLIDAY. The staff of Devon and Cornwall Estates who built Playing Place on holiday in Torbay.

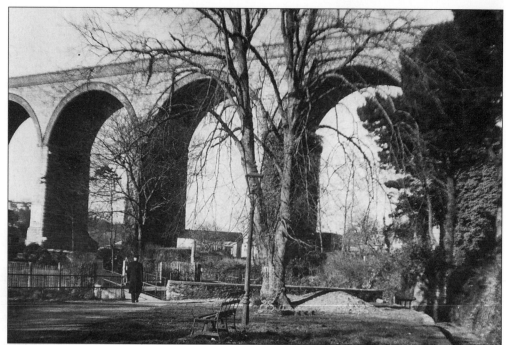

PARKIE. Mr Coombes, known to all the children as 'Parkie', walking through The Leats between Victoria Gardens and Waterfall Gardens in the 1950s. When the park gates were due to be locked for the night Mr Coombes would ring a handbell to warn people. There is no longer a park keeper as such but the bell is on display in the Town Hall.

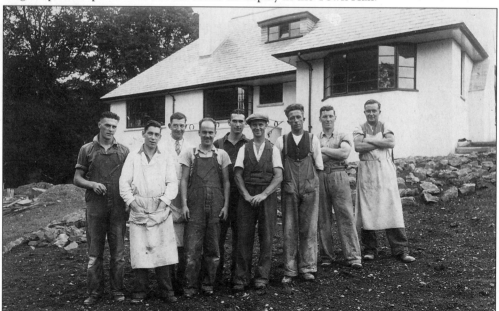

A BYPASS CASUALTY. Workers stand proudly outside a new bungalow in Tregolls Road. Fourth from the left is Frank Davey the plumber. When the garden was completed it was beautiful enough to be the talk of the town but the whole lot was later bulldozed to make way for a road widening scheme.

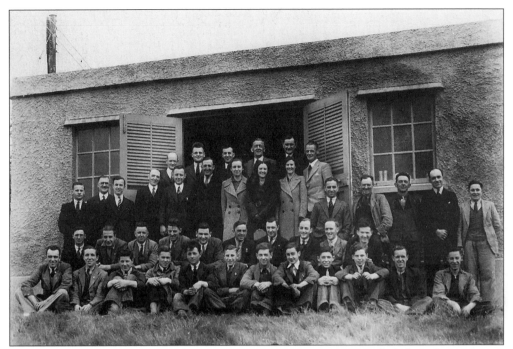

THE CORNWALL ELECTRIC POWER COMPANY, c. 1937. Included in the group are Harold Knott, Jack Netherton, Tommy Mellow, Norman Dash, Frankie Andrews, Stan Dyer, Charlie Annear, Arnold Reynolds, Mr Argall of Portscatho, Mr Bellingham (manager), Fritz Braund, George Roberts, Bunny Austin, Charlie Osborne and Ken Collins. This company was the forerunner of SWEB.

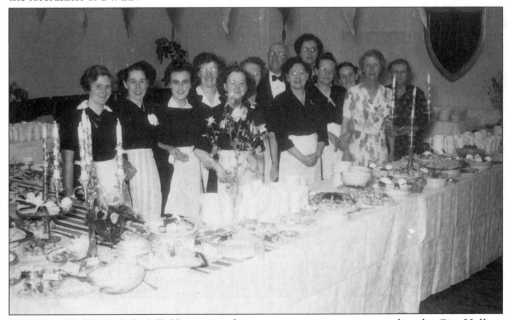

THE STAFF OF TRELEAVENS catering department at a coronation meal in the City Hall on 5 June 1953. Included are Iris Wyatt, D. Vincent, Mr Tonkin and ladies called, Pascoe, Whitcombe, Williams, James and Trebell.

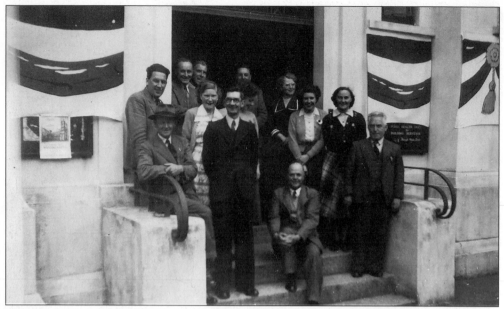

TRURO RURAL DISTRICT COUNCIL. The offices were in River Street and are seen decorated here for the coronation in 1953. Sitting, is the ratings valuation officer Mr E.J. Repper. The gentleman with the hat is the cashier Mr Pryor and behind him Mr Repper's deputy Mr Jim Wilton who took over in 1957.

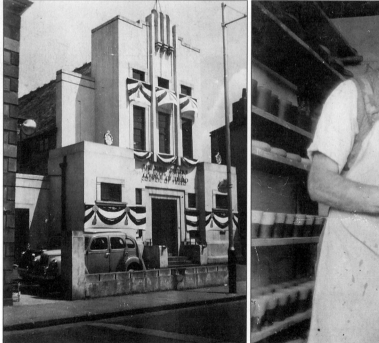

Left: THE RURAL DISTRICT COUNCIL OFFICES. These occupied the site of the Congregational chapel and closed in 1974 with the reorganisation of local government. Right: LAKE'S POTTERY, c. 1950. Russell (Matt) Matthews pulling a handle on a three-handled vase at Lake's Pottery in Chapel Hill.

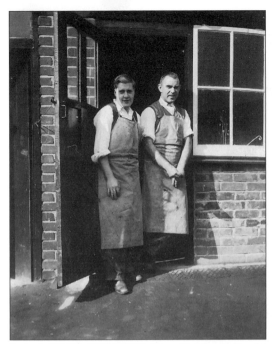 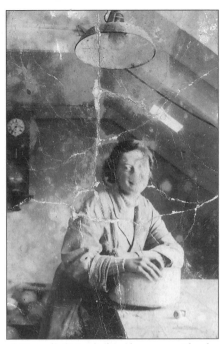

Left: LAKE'S POTTERY. Harold (Sam) Hankins and Russell (Matt) Matthews outside the bawing shed. The bawing shed is where the handles were put onto the pots.
Right: LAKE'S POTTERY. Stella Edwards working in the upstairs fancy-wear glazing room.

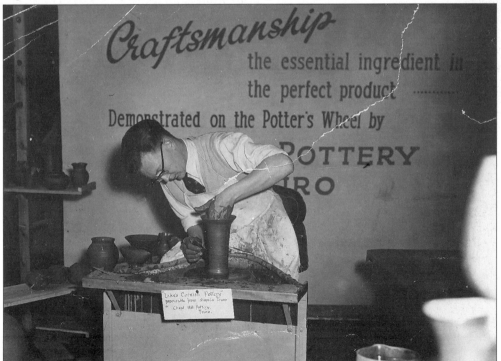

MIKE EDWARDS OF LAKE'S POTTERY. Mr Edwards is demonstrating how to make a selection of pots. He is in the window of the old HTP showrooms in 1953.

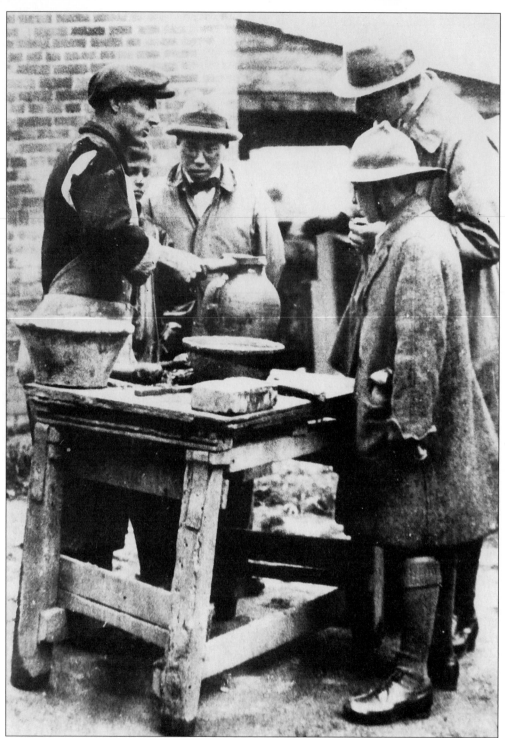

HOW IT'S DONE. Mr Barry Pascoe, wheelman (thrower) at Lake's Pottery shows Bernard Leach and his sons David and Michael, together with Japanese potter Hamada, how to put a handle on a pot. This was in the early 1920s before the Leach Pottery was started.

Four

Leisure Time

In this chapter some of the leisure activities of the people of Truro have been represented. The People's Palace ran many leisure activities including sports and music and if it were still in existence today surely the youngsters could not complain that there was nothing to do and nowhere to go. Without television people were used to making their own entertainment and clubs and societies abounded.

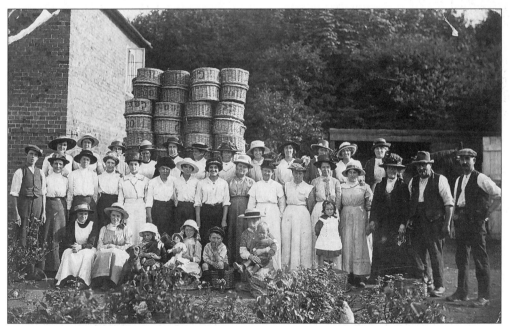

A HOLIDAY IN JERSEY. Found in the effects of the late Clifford Mitchell, this photograph posed a puzzle. Some members of his mother's family (called Ridge) are certainly there. Just before the First World War it was customary for his mother and her sisters to spend their holidays in Jersey - a fortnight of potato or tomato picking. The 'GEO' on the baskets stands for 'G.E. ORANGE', for many years fruit and vegetable merchants in Jersey.

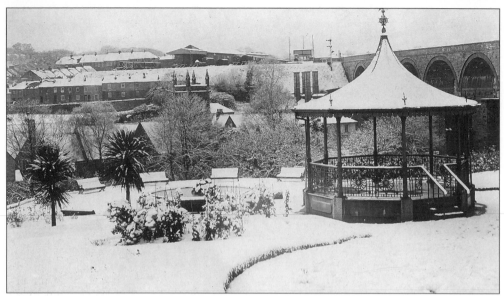

THE BAND STAND. Always a popular place for recreation, Victoria Gardens is deserted in the snow of 1904. It is noticeable that the pond to the left of the bandstand is without the fountain that we see there today as it was still in Boscawen Street. The chimneys of Carvedras Smelting Works can be seen in the background.

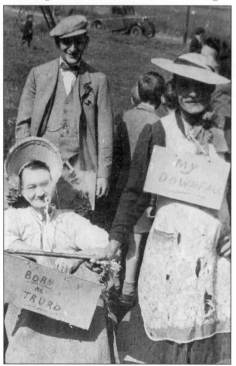

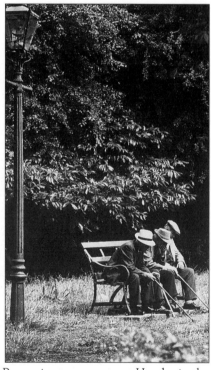

Left: CARNIVAL TIME. Entrants for Truro Carnival Procession congregate at Hendra in the 1920s. 'Born in Truro' and 'My Downfall' are escorted by a dapper Fred Mitchell.
Right: THE TRURO PARLIAMENT, *c.* 1955. The world's problems are set to rights by three elderly gentlemen on the park bench in The Leats by the waterfall.

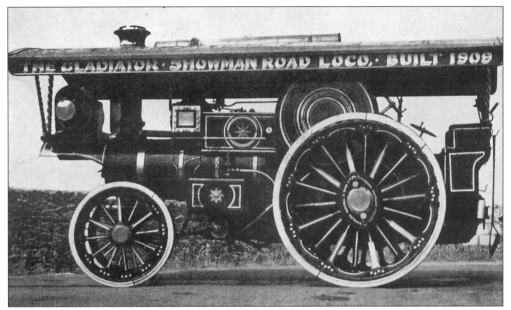

THE GLADIATOR. Transferred to Captain Arthur Rowland's Cornish section in 1921, this 1909 Gladiator was acquired by Whiteleg & Sons in 1932. Renovated at Redruth after lying idle in Launceston and Exeter since 1941, the Gladiator is a familiar sight at Truro fetes and festivals.

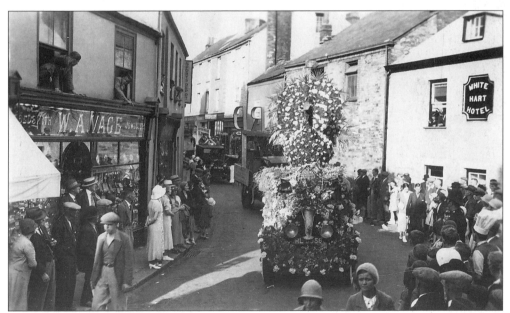

A CARNIVAL PROCESSION, 1935. The floats pass through New Bridge Street past the White Hart, the oldest public house in Truro retaining its original name. Mr William Vage stands in his doorway watching the proceedings. Donald Vage is watching from the right hand upstairs window while Trevor Vage and Ada Grutter are at the other window.

THE BAPTIST CHURCH, *c.* 1910. Members of the River Street Baptist church include, in the front row on the right, Charlie Wright sitting beside his twin sister Katy with their mother behind her. The minister is Revd Seager and the gentleman at the top left is Mr Walters who had a jewellery shop in Victoria Square. Also present are Mr and Mrs Stoot, Mrs Weekes and Jessie Truscott, second on the left.

A HARVEST FESTIVAL. Offerings are laid out at the original City Mission in City Road, founded by Michael Nancarrow. There is a plaque in St Mary Clement, now Truro Methodist church, referring to the City Mission.

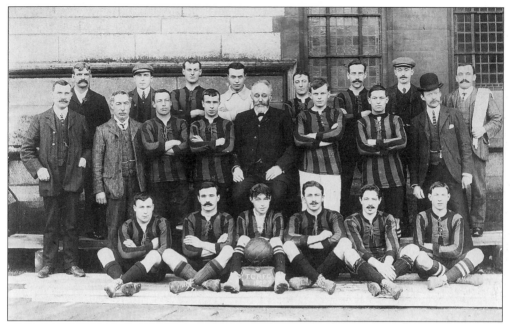

THE CATHEDRAL RANGERS, 1908-09. This football team was made up of men who worked on building Truro Cathedral. It has been suggested that some of them got their jobs because of their sporting prowess. The only established fact is that most of the men regularly enjoyed home-made pasties from Manuell's in King Street.

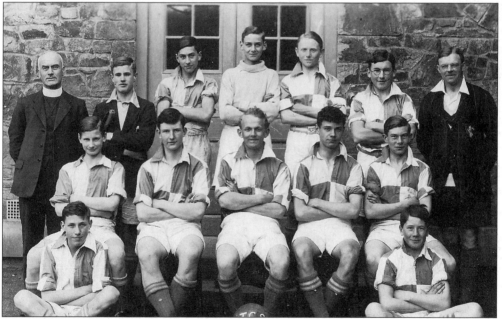

THE CATHEDRAL SCHOOL XI, 1929-30. The school was located behind the cathedral but is now the offices of the Social Services. It was the former Truro Grammar school founded in 1549 and was the Cathedral school from 1906 until it was closed in 1982. In the back row are the headmaster, Canon A.F. Welch and Mr F.H. Humpherson. The boys include Atkinson, Sedgwick, Jesty, Frank Pascoe (front row seated on the ground) and Bill Ratcliffe.

63

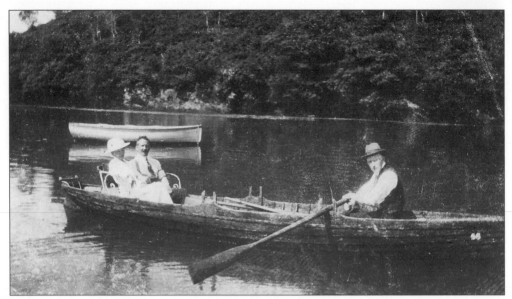

ON THE RIVER. William Vage is rowing his sister and her husband, Ada and Sigmund Grutter on the Truro River, 15 June 1917. Mr Grutter, who was Swiss, was the manager of Opie's photographers in New Bridge Street and Ada worked in the jewellers shop.

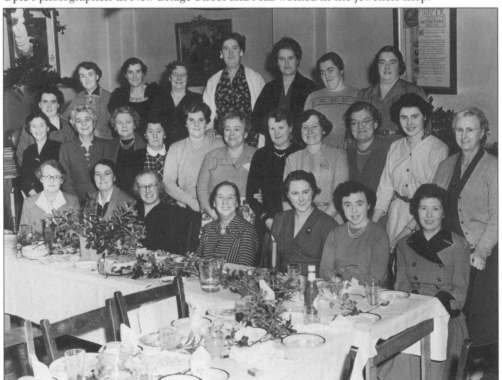

A TUESDAY CLASS. This is Mrs Borlase's class at St Mary's chapel, c. 1960. Mrs Borlase is in the striped dress seated in the centre with Myrtle Odgers behind her. Also in the group are Ada Lapham, Gladys Thomas, Miss Northey, Ruby Holman, Dulcie Braund, Agatha Pellow, Enid Cobbledick, Mrs Medlyn, Mrs Hambly, Ruth Evans, Mrs Taylor and May Penna.

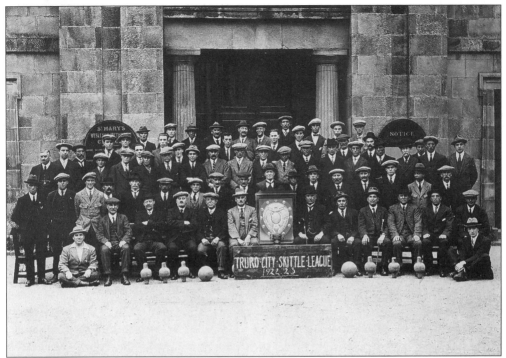

TRURO CITY SKITTLES LEAGUE, 1922-23. Gathered outside St Mary's Weslyan church are skittlers from all over Truro. In the front row, on the left is A.P. Rowe (seated). Behind the shield is Charlie Wright and also shown are Jack Behenna, A. Behenna, Albert Rapsey, Jack Fillbrook, Albert Ferris, W.T. Skimmins, George Pill, Mr Davey, the landlord of the White Hart and J. Roberts the caretaker of the People's Palace.

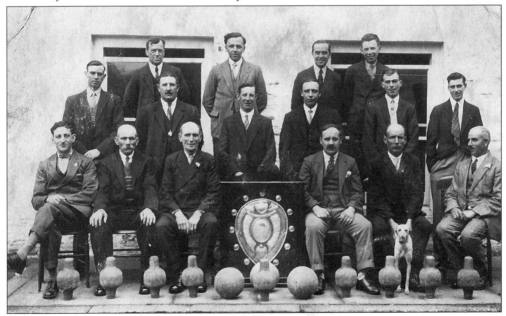

PEOPLE'S PALACE, c. 1920. Believed to be the People's Palace skittles team who appear to have won the league shield. In the front row on the left, is Fred Mitchell, blacksmith.

THE CORN EXCHANGE, 1920. This was in Boscawen Street, where today Littlewoods is situated. A group of Western National staff are enjoying a party. On the right is Mr E.J. Paddy and included in the gathering is Mr Alfred Chapman.

A FANCY DRESS PARTY held in the Womans Institute Hall in St Mary's Street, *c.* 1922. This party was for the staff of the Western National Omnibus Company.

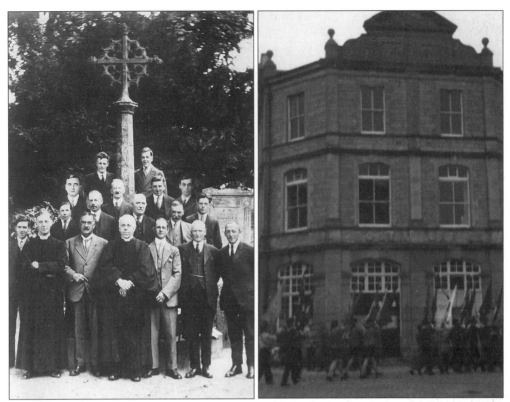

Left: KENWYN CHURCHYARD. Parishioners gather round the cross in the churchyard at Kenwyn, *c.* 1925. Included are Mr Harry Rapsey with his son and Mr Udy who worked in Victoria Gardens.

Right: ON PARADE. A procession of scouts and guides arrives at High Cross and pass the Sylvanus Trevail Post Office building, *c.* 1960.

BOSCAWEN STREET. Truronians watch a parade of servicemen making their way to the war memorial past the gas showrooms *c.* 1958. Soon the gas showrooms and Pearson's jewellers were to disappear. In this composite picture by John James, the granite setts are shown well.

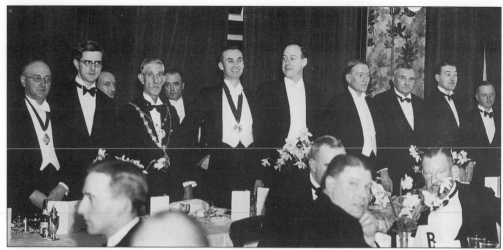

CHAMBER OF COMMERCE DINNER, 1937-38. Those in the picture are, from the left to right: The Chairman of Plymouth Chamber of Commerce, Doctor A.L. Rowse, J. Delbridge (Mayor of Truro), C.I. Roberts (chairman), A.R. Wise (MP), M. Petherick (MP), J. Searle (Cornwall NFU) and W. Evans (Cornish Branch Commercial Travellers).

TRURO AMATEUR OPERATIC SOCIETY, *c.* 1930. A parade of period uniforms displayed by Jack Lampier (centre) and Jack Parnell (second from the right) together with three unidentified members of the troupe.

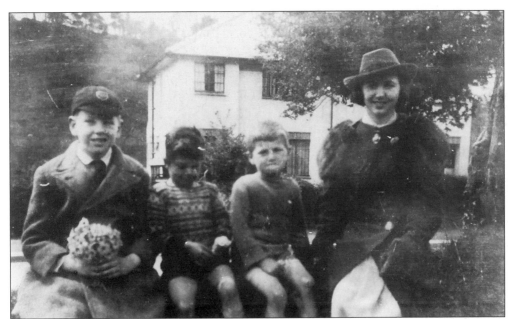

A PRIMROSE PICKING EASTER, 1940. The scene is St Georges Road and on the left is Fred Paddy (later well-known Registrar of Births, Deaths and Marriages and the possessor of the most beautiful copperplate writing), next to John Blight, Neville Paddy and Mary Paddy who worked for the bishop at Lis Escop.

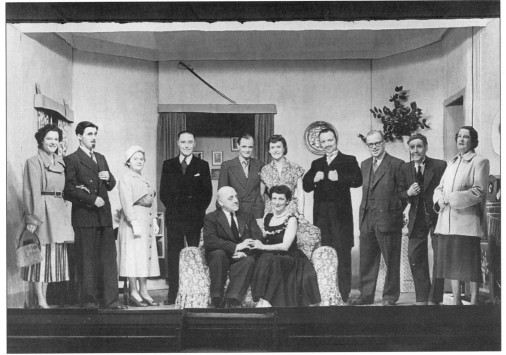

THE PHOENIX PLAYERS on stage at St Georges Church Hall in 1955 are the cast of *Will Any Gentleman*. Leading man Clifford Sharp is on the sofa and behind him are Toby Curgenven and Jack Parnell. To the right of the sofa is Frank Pearce.

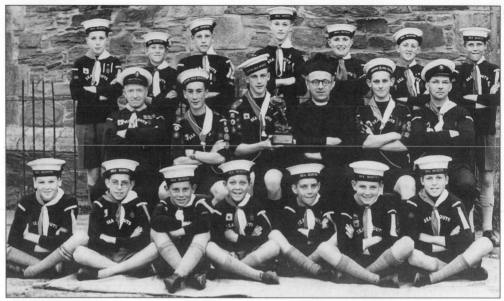

SEA SCOUTS. The Tenth Truro Sea Scouts line up in their base at St Geoges Church, 1950. The vicar is Revd G.E. Hewson and the scoutmaster is Commander Shambrook. The scouts include: Jimmy Penrose, Geoffrey Hicks, John Harcourt, Raymond Guy, Peter Parnell, Geoffrey Murton, Jonathan Warren, David Williams, Horace Tonkin, David Fillbrook, Robert Bachelor and Brian Duke.

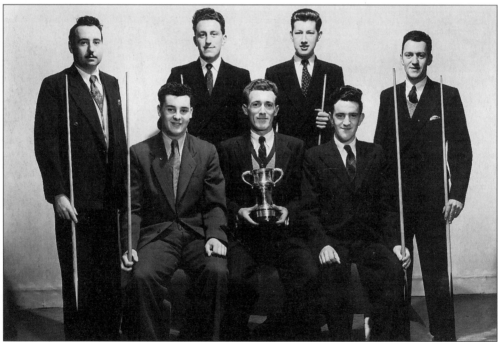

PEOPLE'S PALACE SNOOKER TEAM, *c.* 1950. Egar Collins proudly holds a cup which had just been presented by Mr Christophers. Standing, from left to right: Ray Godwin, Bill Scantlebury, Geoff Carveth, Byryn Mitchell. Seated, from left to right: Brian Pascoe, Edgar Collins and Dennis Mitchell.

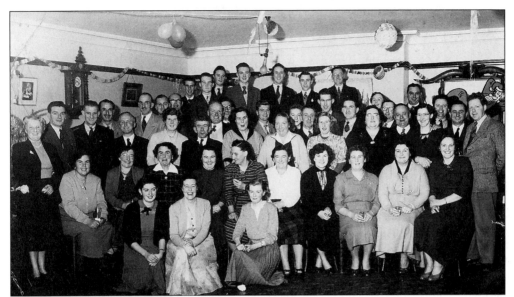

SWEB CHRISTMAS PARTY, *c.* 1955. In the picture are: Jean Eva, Mr and Mrs Donald Hill, Arnold Reynolds, Charlie Annear, Brian Libby, Ken Couch, Tommy Mellow, Frankie Andrews, Oscar Rowe, Mr and Mrs Derek Trebilcock, Peter Richards, Ken Cobbledick, Trevor Gilbert, Percy Gummow, Mrs and Mrs Jack Netherton, Mr and Mrs Norman Tonkin, Mrs P. Richards, Harry Reed, Leonard Pascoe, Tommy Searle, Mr and Mrs Jackie Costa, Freddie James and Cathy Piper.

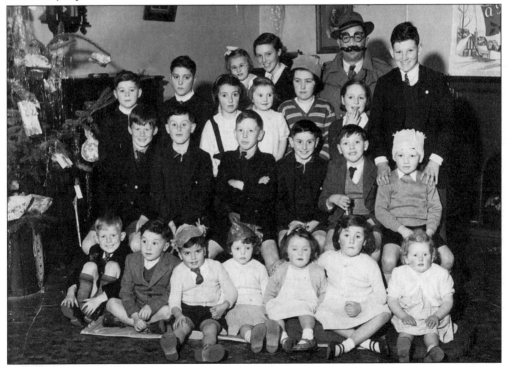

A CHILDREN'S PARTY. These are the children of the parents in the previous picture, except for the heavily disguised 'child' in the back row, who was disclaimed by everybody.

71

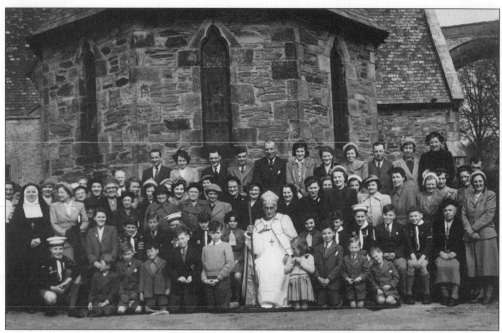

THE BISHOP'S VISIT, 1949. The Bishop of Truro visits St George the Martyr. Amongst the congregation are many familiar faces, including: Graham Runnals, Jack Fillbrook, Ethel Bachelor, David Blake, Geoff Hicks, Horace Tonkin, Patricia Parnell, John Polkinghorne, David Williams, Elizabeth Truscott and Brian Duke.

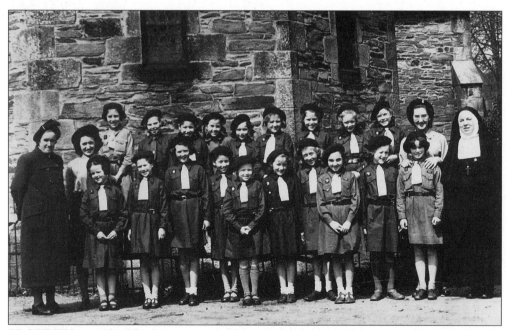

BROWNIES, c. 1950. The Brownie pack of St George the Martyr are shown with their leader Mrs Carter and Sister Margaret. One wonders how many of these charming young ladies are now grandmothers?

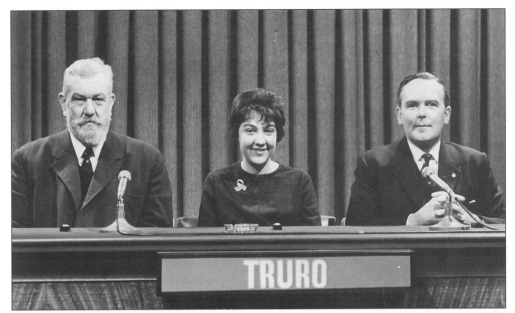

LANDMARK, 1964. The Truro team in the successful Westward panel game shown on ITV, are Commander Pollard, Christine Mitchell and Donald Vage. As Christine was the student in the team she should have appeared in school uniform but the white blouse and black jumper of Truro County School dazzled so much that she was obliged to exchange clothes with her mother, Mrs Margaret Mitchell, who then sat in the audience clad in school uniform.

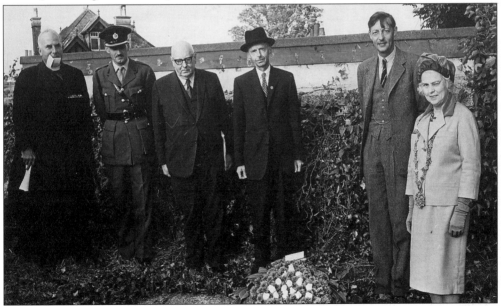

THE TRURO OLD CORNWALL SOCIETY. On 18 June 1965 the society lay a wreath at the grave of the first Lord Vivian to commemorate the 150th anniversary of the Battle of Waterloo. Left to right: Dean Lloyd (Rector of St Mary, Truro), Mr Beeching (Territorial Army Officer), Mr John Rosewarne (President of Truro OCS), Mr Arthur Lyne (Honorary Secretary of Truro OCS), Mr Graham Vivian of Bosahan (descendant of the first Lord Vivian and High Sheriff of Cornwall) and Mrs Mabel Andrews (Mayor of Truro).

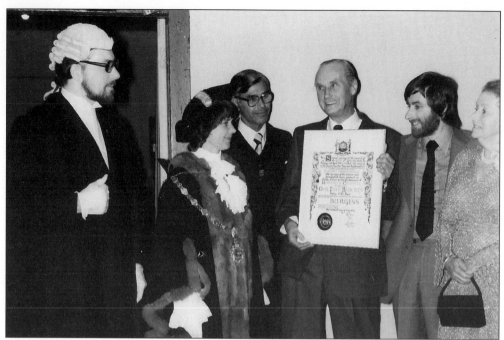

W.J. ROBERTS. Mr Cecil Roberts is made an Honoured Citizen of Truro in 1979. This certificate is presented by the mayor, Mrs Doris Ansari. Also present are Doctor Ansari, Bill Roberts, Mrs Cecil Roberts and the town clerk.

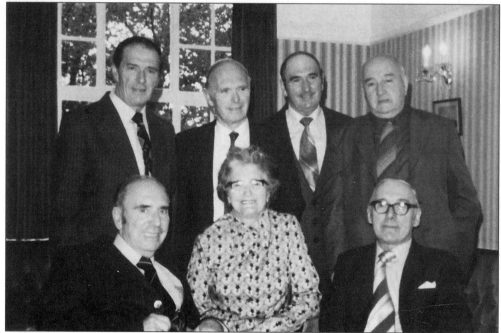

A RETIREMENT PARTY. On 13 June 1979 seven members of the Davey family of Truro celebrate their retirement from various businesses in the city. Grouped around their sister, Mrs Lewarne (greengrocer), are Reg (coal merchant), Stan (deputy manager at the Gasworks), Frank (master plumber), Wilfred (butcher), Jack (carpenter) and Edgar (coal merchant).

Five

Music

The Cornish people have always been musical and never needed an excuse to form a choir or enter a competition. The people of Truro are no exception. There have always been orchestras and dance bands with plenty of venues. Now with the Hall For Cornwall under construction perhaps there will be even more opportunities to make and enjoy music.

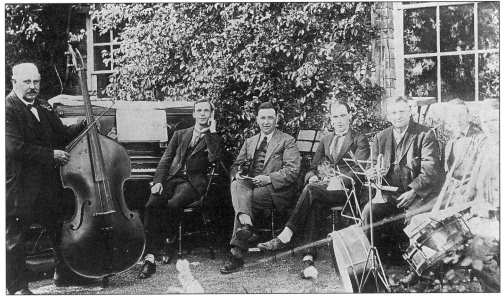

A TEA DANCE is held in the garden of Tregolls House to the music of Edwin James Paddy and his orchestra, c. 1930. Here we have Mr Paddy on double bass with his son Edwin John seated next to the pianist holding his violin. Mr Paddy Snr joined the Ponsanooth Band at the age of 12, then in 1882 he was with the band of the Second Battalion, Duke of Cornwall's Light Infantry. After playing with the Royal Garrison Artillery and the Royal Italian Band he toured with the D'Oyley Carte Opera Company. He later came to Truro where he played with many orchestras and operatic societies and maintained that he had played at most of the great mansions in Cornwall.

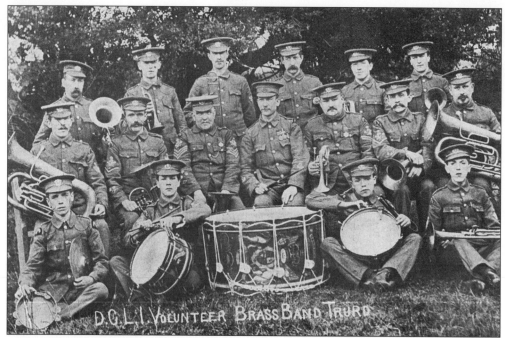

DCLI VOLUNTEER BRASS BAND. Edwin James Paddy showing his versatility with a large brass instrument in about 1914. He is seated at the right in the middle row.

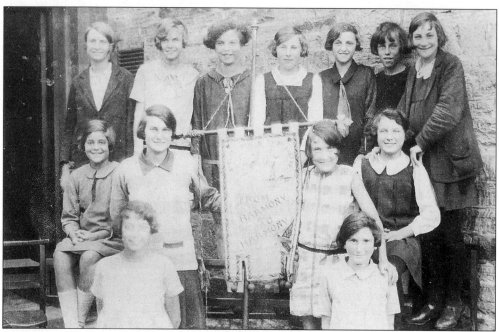

HARMONY BANNER. Girls from St Mary's School in Pydar Street look pleased at having won the banner for their singing in the mid-twenties. Back row: M. Tregonowan, I. Holland, M. Lean, J. Jill, I. Gay, L. Bowden, M. Kingman. Middle row: E. Penhaligon, E. Varker, L. Beards, M. Pearce. Front row: D. Murton and I. Wyatt (nee Salmon).

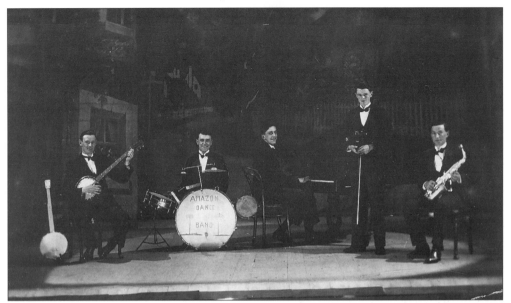

AMAZON DANCE BAND. This band played in and about Truro during the 1930s. A young Jack Parnell is standing with the violin.

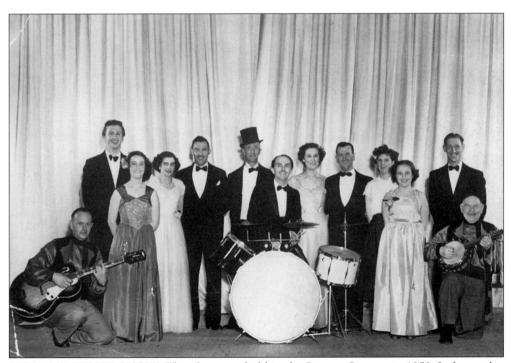

BITS AND PIECES SHOW. This show was held in the Regent Cinema in 1952. Left to right: Harold Hay, Neville Paddy, Margaret Curgenven, Vera Milne, Harold Satterley, George Davey, Peter Hill, Erstine Thomas, Alf Hoskin, Dot ?, Margaret Ivey, Bill White and Bob Hay.

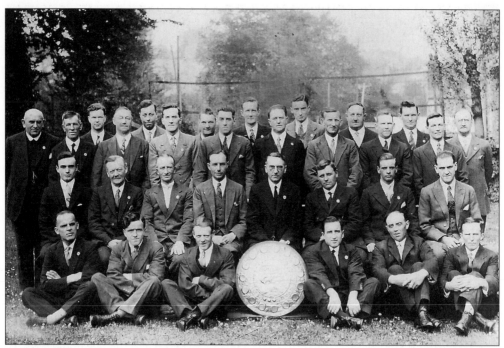

THE PEOPLE'S PALACE MALE VOICE CHOIR won the Cornwall County Music Festival Copper Shield in 1930. The conductor, holding the shield, is Bertram Lightbown.

THE CARNON VALE CHOIR is pictured during the Second World War.

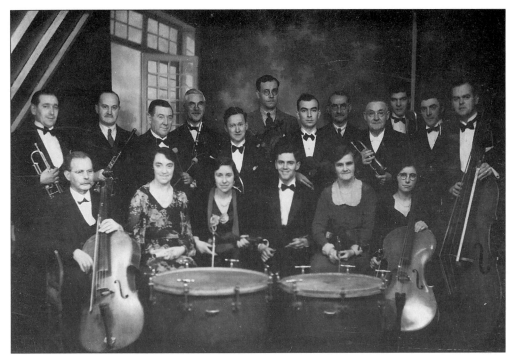

THE TRURO CITY ORCHESTRA. The date is uncertain but is believed to be during the twenties. John Odgers is on the far right in the back row, with his double bass. Also in the picture are Howard Rule, Mary Rundle and Olive Ferry (nee Scoble).

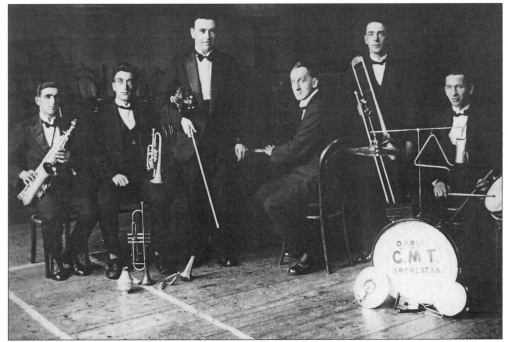

THE CMT ORCHESTRA. The Cornwall Motor Transport Dance Orchestra performed in the 1930s. With John Paddy on violin, John Harcourt at the piano and Mr Haynes on the trumpet.

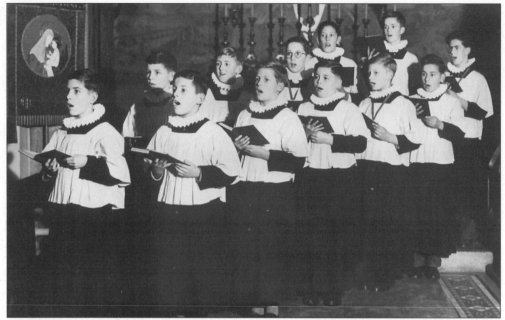

THE CHURCH CHOIR. The treble section of the choir of St George the Martyr seen in about 1951. Back row, from right to left: Peter Parnell, Raymond Guy, Geoffrey Hicks, Geoffrey Murton, Bobby Bachelor. Front row, from right to left: John Polkinghorne, Bert Barberry, Alan Brown, David Haynes, Brian Duke, Horace Tonkin and David Fillbrook.

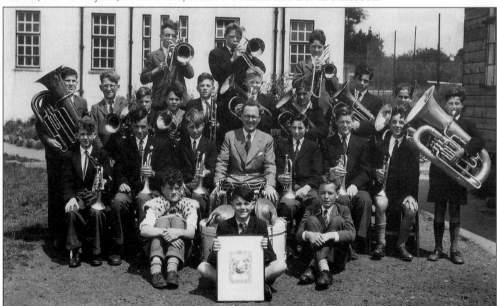

THE SCHOOL BAND. Master in charge of the band, A.J. Newton, is surrounded by the Truro School Band in 1952. Young Mr Boggia is seated in front holding the framed parchment and other members are, back row: Philip Bardsley, Graham Hall, Jeremy Knights. Standing: Gribble, C.E. Marsh, S.R. Mitchell, Tim Harvey, Gluyas, Bordeaux, Tilt, Oliver, R.R. Johnson. Seated: Haycock, Clive Phillips, Mike Williams, Mr Newton, Viner, J.R. Williams, Daniel. On the ground are Wilkinson, Boggia and Kuffer.

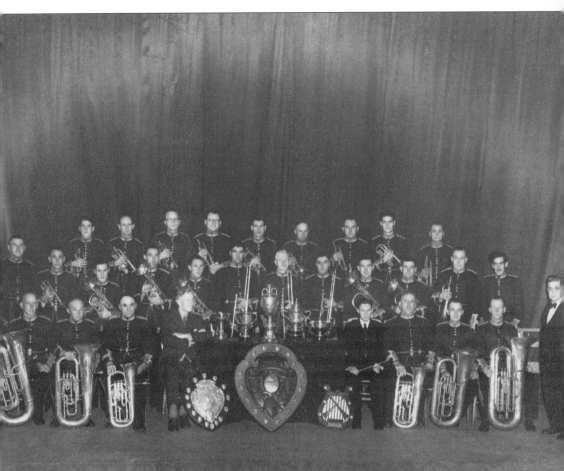

TRURO CITY BAND, 1950. A photograph taken in the Regent and the members are: Back row, left to right: A. Clift, L. Piper, R.G. Stone, F. Braund, A. Andrew, C. Reed, A.F. Furse, J. Nicholls, J. Bedding. Centre, left to right: A. Lamerton, F.A. Allen, E. Pooley, A.H. Heayn, A. Verran, W. Clift, F. Harding, J. Clift, K. Heayn, C. Jones, S. Heayn, G. Wilton. Front row, left to right: E. Tremaine, W. Hodge, G. Trevarton, W.J. Russell (chairman), S. Morris (bandmaster), W. Tremaine, C. Harding, R. Medlin and A.W. Parker (musical director). They had four successes during 1950: Area champions for the *Daily Herald*, West of England champions, Mid-Cornwall champions and SWBB Association champions.

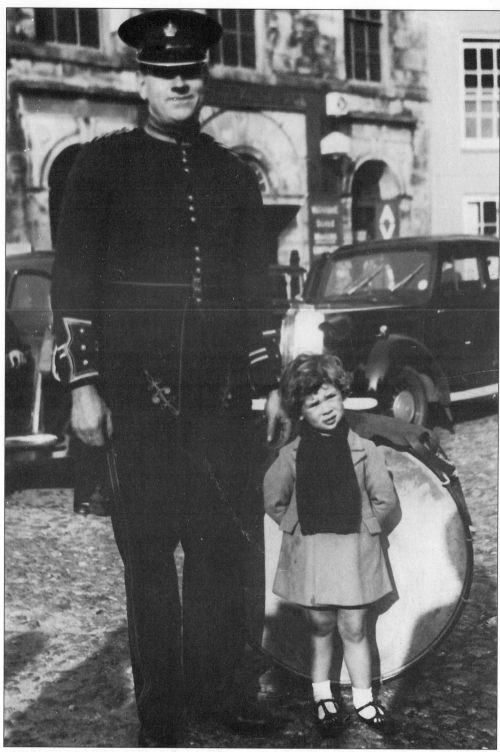

THE BASS DRUMMER, Mr Albert Lamerton poses with his nephew Dennis at High Cross in 1938. Mr Lamerton was bass drummer with Truro City Band for 35 years.

Six
Schooldays

Most of the schools which existed in Truro during the era of this book have been included in this chapter but unfortunately it has not been possible to cover all of them. The author has put many names to faces but there are some gaps. Today there are new schools with new names, all of them far too modern for them to be included here.

OFF TO SCHOOL. Julia Feltham and Marjorie Parnell set off from Courtney Road, on a sunny day just after the Second World War, to go to school.

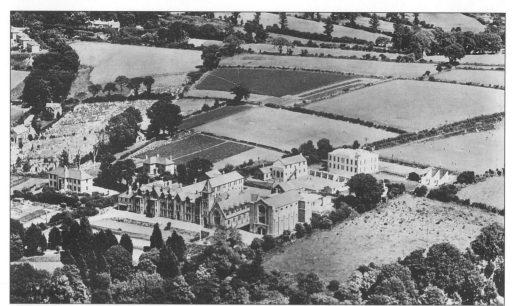

THE TRURO SCHOOL. The 'new' science block looks rather isolated in this aerial view in about 1950. Today many more buildings have been added. To the left of the picture is the public cemetery in St Clements Hill.

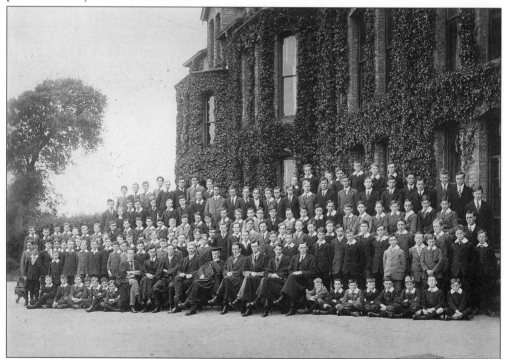

THE ENTIRE SCHOOL, c. 1920. The staff and pupils of Truro School pose outside the ivy-clad front of the main school building. The headmaster is Doctor Magson and the boy who is eighth from the right, seated on the ground, is Cyril Penna. His brother Philip is above him in the very back row. Both boys were in the Hawken family, tailors, famous for the golden ram which hung over their shop and which was eventually stolen.

84

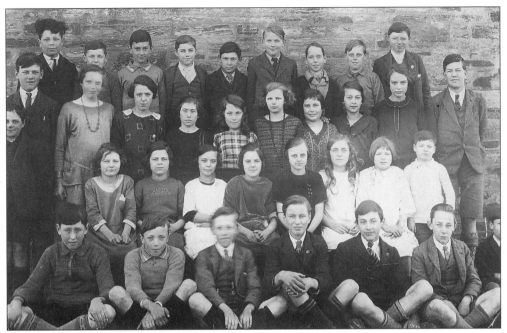

THE KEA SCHOOL PUPILS, *c.* 1920. Unfortunately the author cannot put a name to any of the pupils but perhaps somebody out there can.

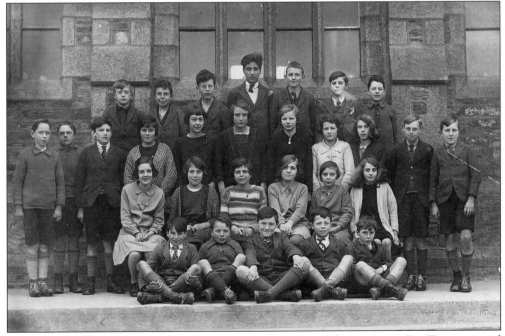

THE KEA SCHOOL, 1928-29. Standing on the far right of the picture is Jim Tregunna and beside him is Jim Gunn. The former is a well-known retired plumber and the latter may be seen today happily pottering about Coombe Creek.

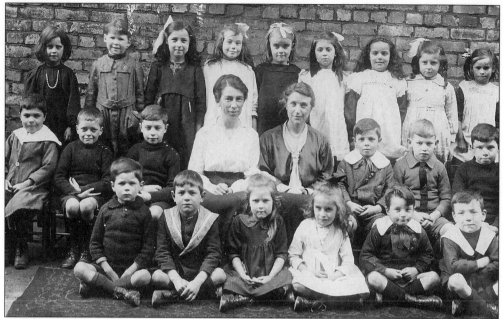

ST MARY'S SCHOOL, *c.* 1920. Second from the left on the middle row is Chester Odgers, but the author is unable to name the others. The school itself (pictured opposite) was in Pydar Street but was pulled down during the 1960s.

ST MARY'S SCHOOL, *c.* 1934. The children are seen here posing in front of the bicycle shed. Back row, left to right: Dennis Allen, Alan Carveth, ? Brewer, John Salmon, Pat Marshall (Trehaverne), Jean Chapman, Edith Hocking, Gwen Allen, Kenny Richards, Manley Kendall. Middle row, left to right: Jean Wilton, -?-, Gerald Stephens, Iris Hall, Vera Gallie, Jean Gay, -?-, Gordon Richards, -?-, Selwyn Davies. Front row, left to right: -?- (from London), Maureen 'Bunty' Allen, Isabel Miller, Pat Teague, Peter Perrow, Cecil Richards, Monica Pascoe, Pat Marshall (Newham), Avis Kellow, Beryl Harris, Monica Tyack.

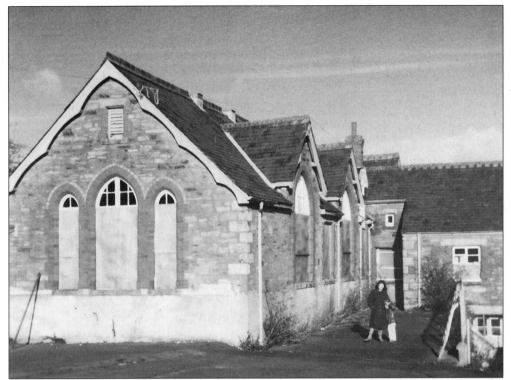

ST MARY'S SCHOOL. The school was boarded up prior to demolition during the 1960s. The site in Pydar Street is now occupied by the Ministry of Agriculture, Fisheries and Food.

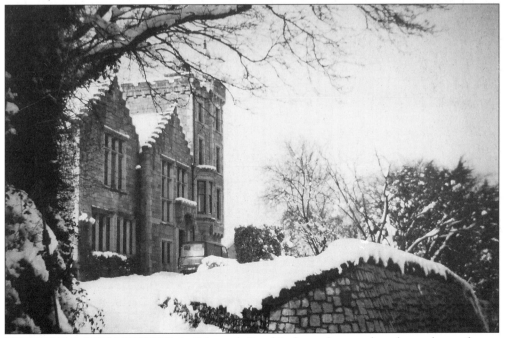

THE TRURO HIGH SCHOOL in Falmouth Road is shown here under a heavy layer of snow in 1963.

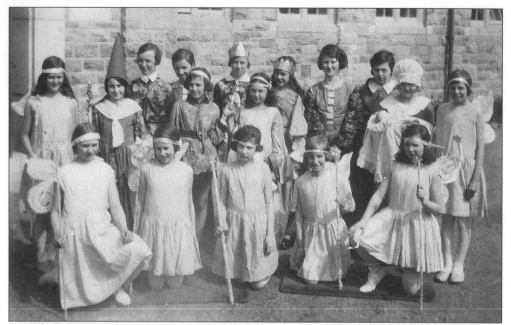

THE TRURO COUNTY GRAMMAR SCHOOL. Girls are dressed for a school play in the 1920s. In the back row is Gertrude 'Nellie' Pengelly and beside her is Phyllis Phoebe who later became the headmistress at St Erme School. Violet Hill is in the front row.

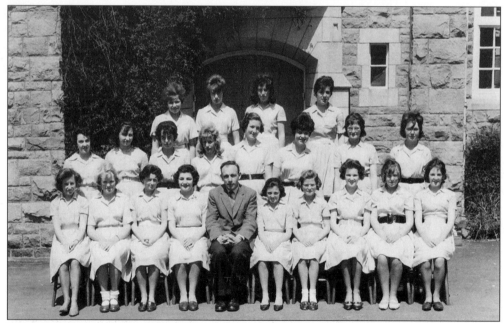

FORM THREE ALPHA, 1961. Truro County Grammar school girls are wearing summer uniform and squinting into the sun. The form master is Mr D.M. Hobba, known as 'Yogi'. The girls are, back row, left to right: Carol Pavey, Carol Hooper, -?-, Corinne Waters. Middle row, left to right: Christine Mitchell, Barbara Duckworth, -?-, -?-, Janet Hoskins, Elaine Muller, Christine Hurst, Delia Mason. Front row, left to right: Jenny Crabb, Susan Richards, Judith Solomon, Elaine Hawkey, Christina Turner, -?-, Janice Barnicoat, Diane Pascoe, Jill Meyrick.

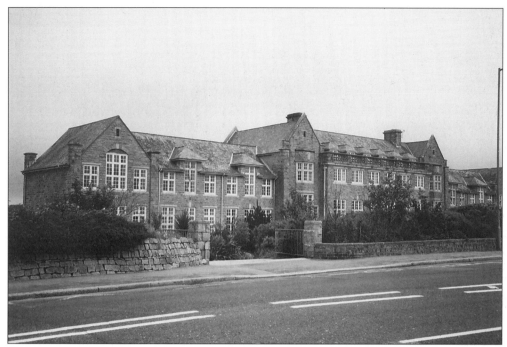

THE TRURO COUNTY GRAMMAR SCHOOL. The foundation stone was laid in 1925 and the building graced Treyew Road until it was demolished to make way for a supermarket in the mid 1990s.

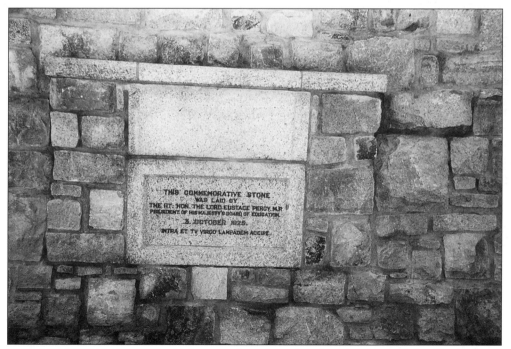

THE MEMORIAL STONE which was taken from its place in the wall beside the front entrance to the school and is now at the foot of the steps in Station Road leading to Sainsbury's.

A SCHOOL REUNION, 1956. Staff and former pupils of Truro County Grammar School for Girls congregate on the hockey pitch for a photograph. Second from the right is Mrs Carter, a teacher who also ran the St George's brownie pack. Fourth from the left is Margaret Wright (nee Selvey).

TREMORVAH JUNIOR SCHOOL, 1957. The headmaster Mr Teague addresses a group of children and parents. In the background, across Mitchell Hill is the Rising Sun Inn. The school has long since been demolished but the pub has survived.

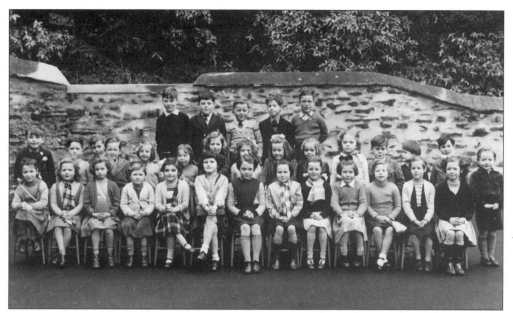

ST PAUL'S INFANTS, 1954. This was a Church of England school situated next to St Paul's church. The back row includes: Kevin Timms, Alex Clift and Raymond Sandercock. The middle row includes Peter Long, Freda Viant, Sandra Bishop, Donald Rowe and Peter Scantlebury. The front row: Susan Franklin, Yvonne Pye, Joy Rapsey, Elaine Hawkey, Kay Harris, Christine Mitchell, Elizabeth Stethridge, Wendy Basnett, Jennifer Polmear, June Manning and Kathleen Stephens.

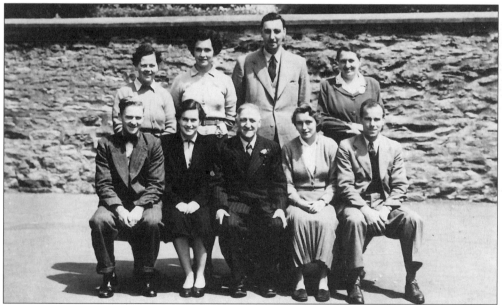

THE STAFF OF TREMORVAH JUNIOR. When pupils finished at St Paul's Infants school they went to the 'big' school, which was Tremorvah Junior at the top of Agar Road. Seated in the front row, in the middle, is the headmaster Mr Teague and in the back row on the left is Mrs E.C. Parnell the school secretary. In the back row on the right is Mrs Vincent who prepared pupils for the Eleven-plus examination.

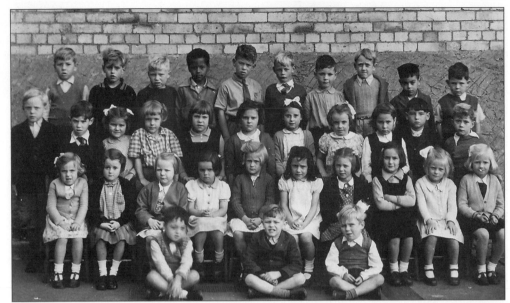

THE BOSVIGO SCHOOL, 1946. Amongst those shown in this infants class are: Manny Cockle, Bobby Bachelor, John House, Patricia Parnell, Gloria Whitford, Sheila Murphy and Margaret Singleton.

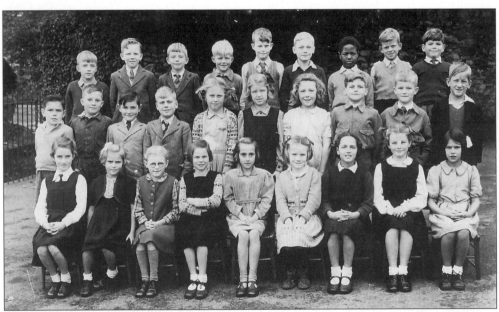

THE BOSVIGO JUNIORS, 1946. Back row, left to right: Brian Robinson, Michael Pearson, -?-, Lenny Pascoe, -?-, Paul Edmonds, Victor Cockle, Peter Brown, -?-. Middle row: Preston Williams, Brian Johns, Derek Chester, George Lovering, Alfreda Bosanko, Dawn Pinfield, Violet Curnow, Terry Wyatt, Peter Parnell, John Woodman. Front row: Janet Stoot, -?-, -?-, -?-, Pearl Williams, Angela Ould, Janet Rule, Madeleine Yeo and Brenda Pegley.

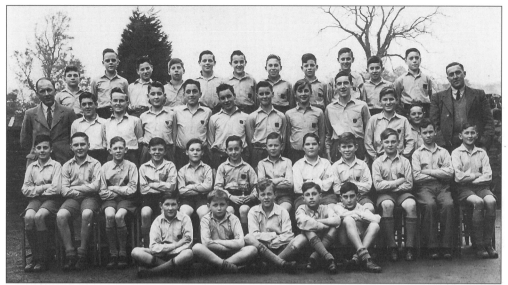

THE TRURO SECONDARY MODERN BOYS SCHOOL which was always known locally as 'The Tech'. This photograph shows the school choir in 1949. Back row, left to right: John Harvey, Gerald Eathorne, John Polmear, ? Allen, John McCoughlan, Roy Whitford, Brian Foster, ? Franklin, Brian Penhaligon, Derek Clift, Douglas Hill. Middle row: Mr R.H. Oliver, Allen Clift, Ronald Ward, Brian Courts, Bill Scantlebury, Frank Pascoe, -?-, Neville Paddy, John Palmer, Kingsley Wright, Edward Benallick, Mr S.C. Lavin. Seated: John Pascoe, Peter Richards, John Pearce, ? Whitford, Brian Libby, Arthur Dennis, Derek Tonkin, John Wills, -?-, Eric Lawton, ? Kelly, Percy Tippet. Sitting on ground: Brian Hayes, Teddy Webber, Brian Trewhella, Roger Heayn and George Richards.

THE DOLPHIN. This piece of stonework was once in the wall of the Fighting Cocks Inn, later the Dolphin Buttery, in Quay Street. When the building was altered the dolphin was moved to Boscawen Park, where it can be seen today. The dolphin was incorporated into the emblem of Richard Lander Comprehensive School as Lander was born in the Fighting Cocks Inn.

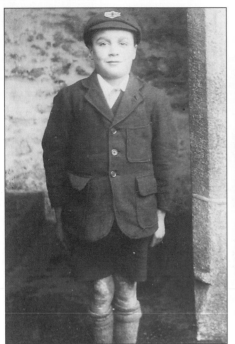
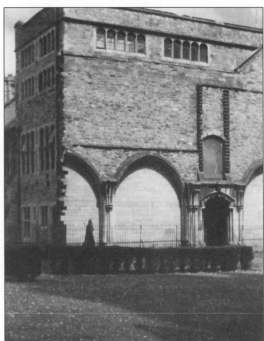

Left: BEFORE SCHOOL, 1925. Fred Mitchell poses for the camera before leaving home for St Georges School. It is doubtful that he looked this neat and tidy on the way home!

Right: THE CATHEDRAL SCHOOL. The building is shown the way the builders left it, intending to join it to the cathedral at a later date. This never happened and today the building is occupied by the Social Services Department, the school having left it in 1960.

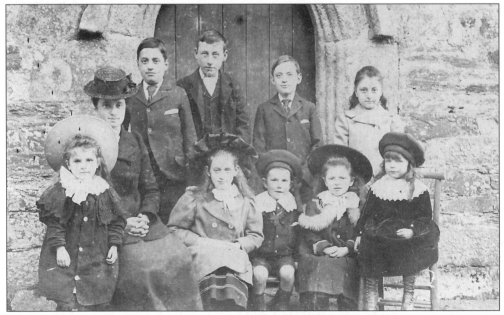

THE SUNDAY SCHOOL. A group of children from the St Clement's Sunday school pictured with their teacher outside the church door in about 1890. In the front row on the left is Evelyn Andrew and second from the right is her sister Ann Bath Andrew.

Seven

Wartime

The people of Truro certainly 'did their bit' during both World Wars and even today, fifty years later it is noticeable that there is a shared comradeship amongst people who served together in one capacity or another.

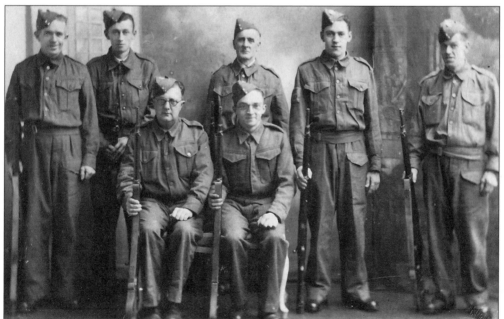

HOME GUARD, 1939-45. Members of 'A' Company stationed at Truro. Standing, from left to right are: L. Stephens, ? Hunt, ? Benbow, Byrn Mitchell, ? Waters. Seated are: ? Tonkin and Jack Dingle.

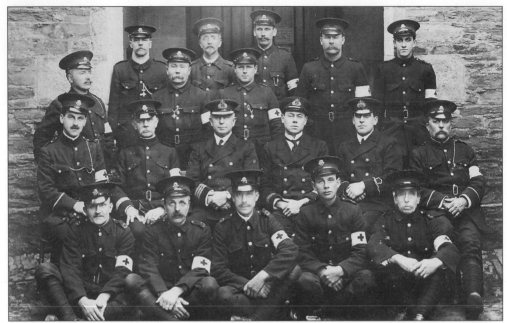

RED CROSS VOLUNTEERS, 1914-18. At the bottom left, in the front row, is John Henry Vage who ran the City Turning Works at No.97 Kenwyn Street, which he took over from his father. Also present is Mr E. Webber (second right, top row) and Mr Seymour of Collett & Seymour, above Mr Vage.

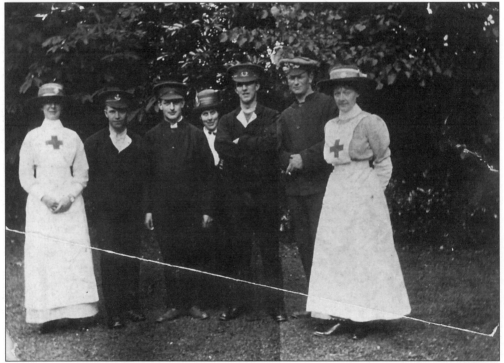

NURSING CARE. Walking casualties of the War are shown with three Red Cross nurses. Fred Mitchell (third from left) was gassed at Ypres.

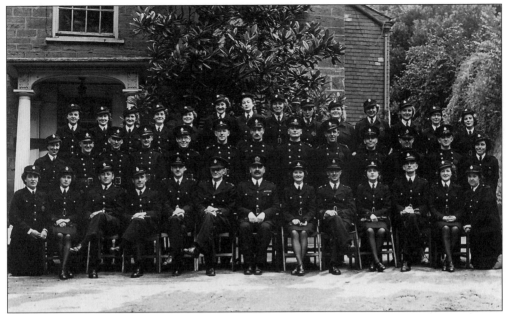

THE NATIONAL FIRE SERVICE, 1943-44. This photograph was taken at Poltisco. Quite a few of these firemen came from London and Bristol to have a break from the bombing, but many Truro people are here too. On the top row, third from left is Iris Wyatt and fifth from left is J. Nicholls. On the middle row, fourth from left is Jack Parnell and seventh from left is Jack Lampier. Also included are M. Kingman, I. Allen, P. Thomas and V. James.

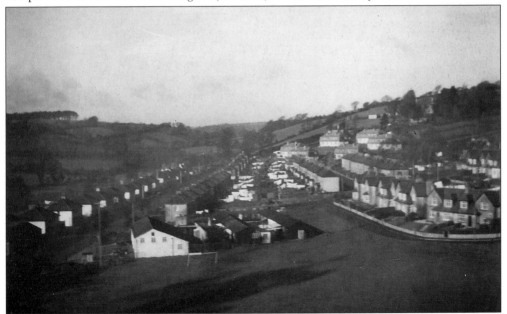

THE NATIONAL FIRE SERVICE HEADQUARTERS, 1939. During the War the fire brigade was allowed to build at Dreadnought Playing Field on land which was given by Lord Falmouth to the people of Truro for recreation. It took a while, but after the War the fire brigade moved out and a swimming pool and squash courts were built. This photograph was taken from the viaduct and looks over Hendra to Coosebean beyond.

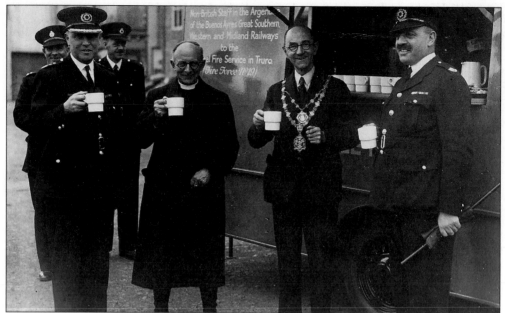

A GIFT FROM ARGENTINA. This canteen was given to the NFS by the people of Argentina. Shown here are Mr Kemp, the mayor, Doctor Hunkin, the Bishop and the District Officer (holding the cane). When a bomb was dropped on Swan Vale Oil Field, Mrs Iris Wyatt, Jack Lampier and Jack Body were on hand with the canteen to supply cold drinks.

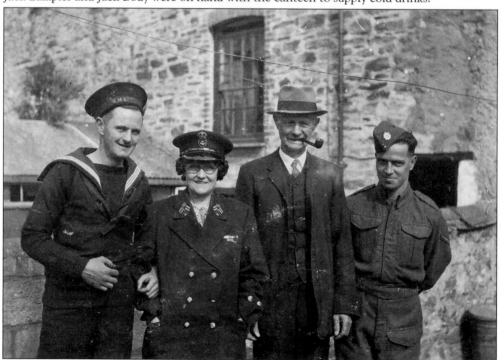

THE FAMILY WAR EFFORT, 1939. Pictured at the rear of No.10 Edward Street are George Parnell, with his mother Ellen Jane and father Clear, plus his best friend, Jack Stethridge, who together represent the Royal Navy, the Post Office and the Army.

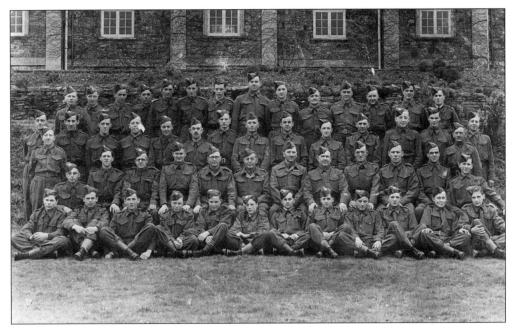

THE HENDRA HOME GUARD, 1939. Based at Hendra Drill Hall, this company was seen frequently marching about in the vicinity of the playing fields.

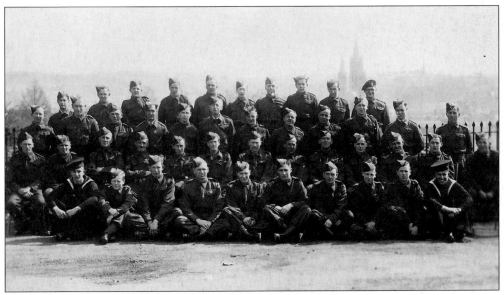

'A' COMPANY, HOME GUARD. Based at Truro Railway Station, this company is pictured at the station with the cathedral behind. Members of this company spent many cold, draughty nights guarding railway tunnels.

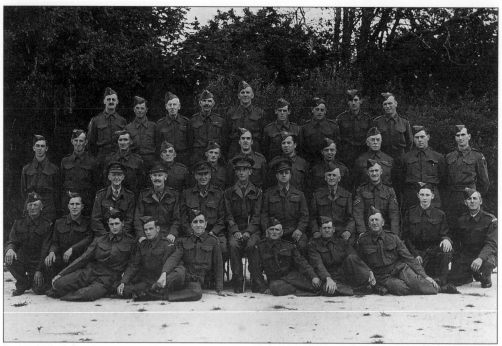

THE KEA HOME GUARD. It certainly looks as if Truro and District was well protected on the home front.

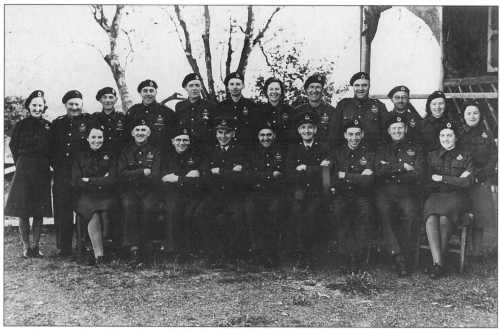

THE ROYAL OBSERVER CORPS. Crew 'B2' at their Truro Centre in April 1943. Top row, from left to right: Molly Metz, Ken Winhall, Mr Roberts, Len Hodge, Jock Forbes, Arthur Lyne, Miss Griffiths, Clary Grose, Mr Martin, Mr Leigh, Mrs Edwards and Emma Woolcock. Front row from left to right: Gladys Chappell, Ernie Clemens, Mr Behenna, Charlie Thompson, Mr Mogg, Sidney Roseveare, Cyril Ruse, Don Hill and Kay Thomas.

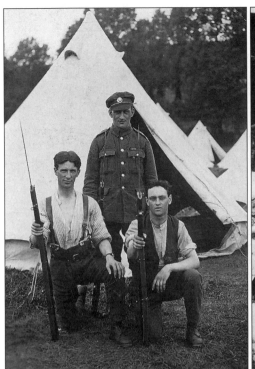
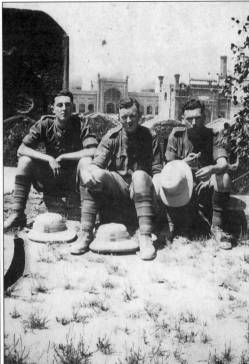

Left: STATIONED IN FRANCE. Truro blacksmith, Fred Mitchell wearing a tunic, poses with colleagues in France during the Great War.

Right: THE CORNISH IN INDIA. Truro boy, Mr Hawke poses in front of the old fort at Lahore in 1940, flanked by Falmouth's Mr Pomeroy and Camborne's Mr Kneebone.

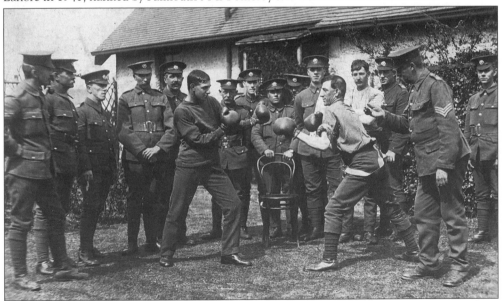

LETTING OFF STEAM. A group of soldiers in the Great War watch Truro's John Mitchell (or his brother Will), with the rolled-up sleeves sparring with a colleague between skirmishes with the 'proper' enemy.

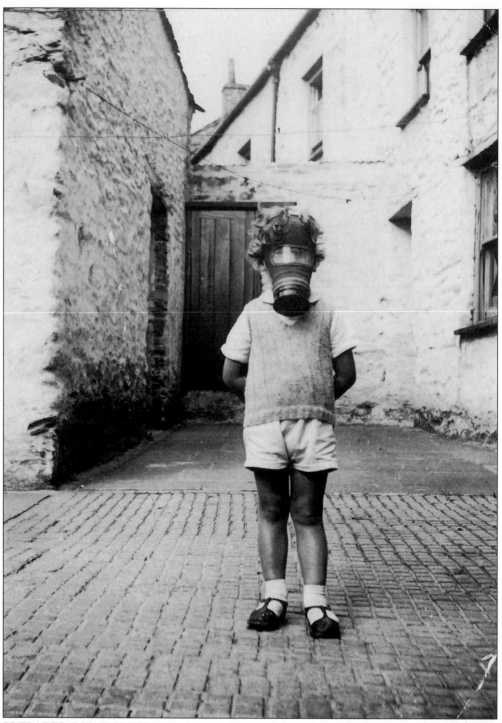

PREPARED FOR THE WORST. A young Dennis Lamerton testing his gas mask in 1940. He is in the courtyard behind his grandmother's house, a two up, two down cottage at No.38 Pydar Street. The cottage had no running water, nevertheless eight children were successfully raised there.

Eight
Transport

Gone are the days when elegant carriages pulled by smart horses graced Truro. It must have been hard work for the horse as unless one left Truro by going to Malpas and over the little ferry, it was up-hill whichever way was chosen. This chapter shows a selection of transport, some for work, some for leisure.

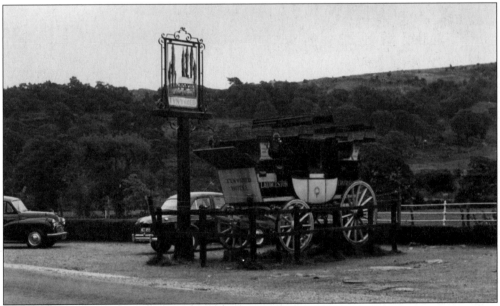

THE OLD CORNISH COACH. This coach, now to be found at Tyn-y-Coed, North Wales, was used regularly to travel through Cornwall, with the towns of Launceston and Truro marked on this side of it. It has been suggested that this could be the Quicksilver Coach which used to stop at Pearce's Hotel (now The Royal) in the 1850s. The Quicksilver would leave Falmouth each morning bound for London, arriving at Launceston in time for an evening meal.

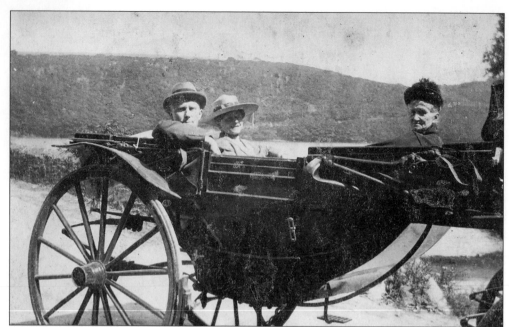

A HORSE-DRAWN CARRIAGE. William Vage and his sister Ada are sitting in this carriage with their mother at King Harry Ferry in the early part of this century.

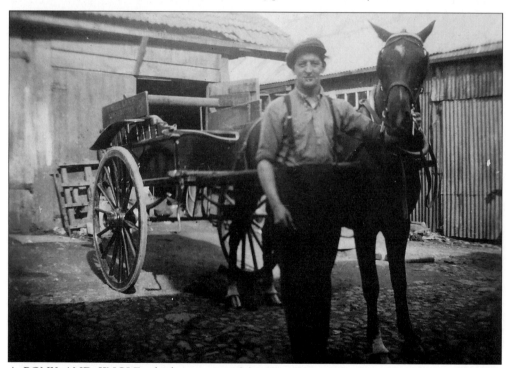

A PONY AND JINGLE which was owned by W. Clarke. The horse is held by Frederick Woodward Mitchell in the blacksmith's shop at No.108 Kenwyn Street in 1925. Note the cobbled yard laid down 700 years ago by the Dominican monks. Although they are still there today they have been covered over by concrete.

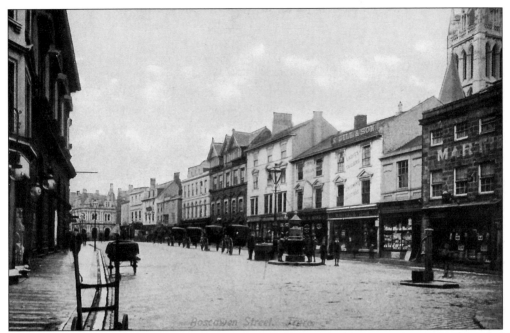

A TAXI RANK. A line of horse-drawn taxis waits patiently for passengers in the centre of Boscawen Street before the Great War. The town pump can be seen clearly, plus the fountain which was later moved to Victoria Gardens.

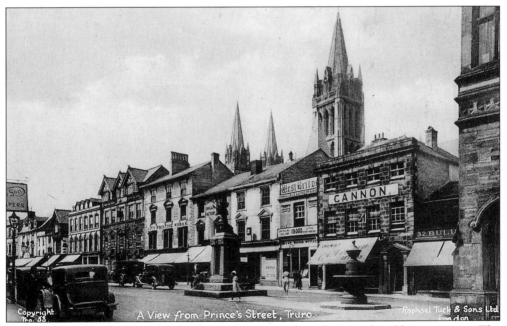

MOTOR TAXIS. By the 1920s the horse-drawn taxis have been replaced by motor cars. The war memorial, erected in 1922, now occupies the site previously taken by the fountain. The fountain seems to have replaced the pump. The car on the left of the picture has the registration number CV1100 which would be much sought-after today.

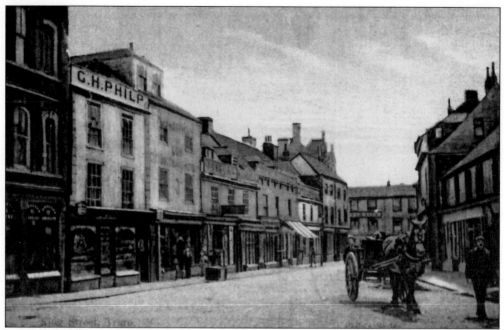

A HORSE AND CART. Plodding along King Street towards High Cross is a tradesman's vehicle in 1906. G.H. Philp was a photographer who took this picture.

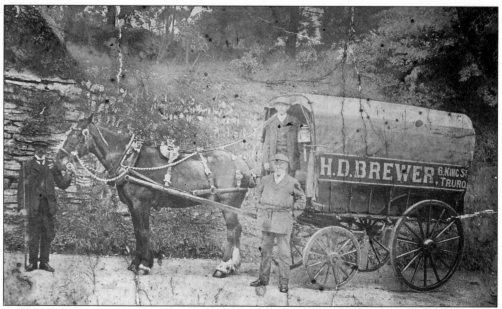

A GROCER'S DELIVERY CART. H.D. Brewer took over the grocery and tea blending shop at No.6 King Street from John Crowle Juleff, his father-in-law, at the turn of the century. His delivery van travelled all over the area. As well as groceries he sold vinegar from the barrel, fresh oranges and paraffin for lamps. He had a tea blending machine in his shop as, like his father-in-law, he specially blended the tea to suit the Truro water.

PEDAL POWER. Charlie Wright, painter and decorator in the 1930s, stands proudly beside his transport. Note the can of paint hanging from the handlebars. If he had a large job to do he would use his hand cart. It was not unknown for Charlie to load his hand cart at 5a.m., walk to Perranporth, spend the day working and not come home until the job was finished, perhaps several days later.

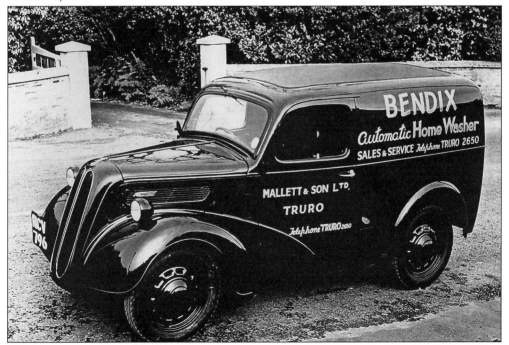

A DELIVERY VAN, 1938. This smart van served the firm of Mallet & Son, who were agents for the Bendix Washing Machine Company. (see also Mallet's window display, Chapter 1 p18).

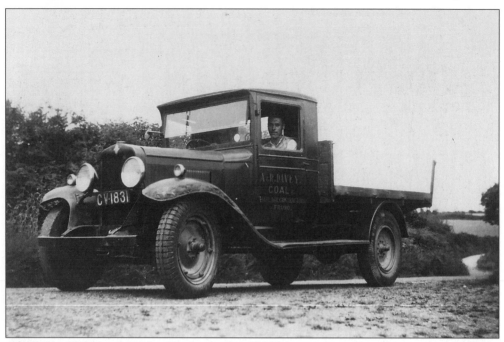

A COAL LORRY with Arthur Davey inside, *c.* 1930.

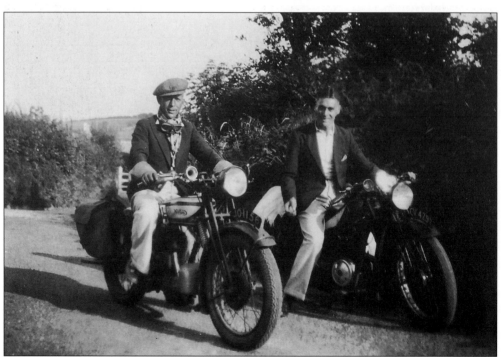

MOTOR CYCLES. Two Davey brothers showing off their motorbikes at Playing Place in the 1930s.

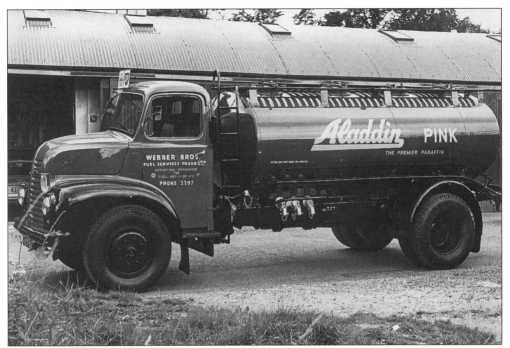

A 1947 LEYLAND COMET. This lorry was bought by Webber Brothers as a second-hand vehicle and painted in their livery. It was used to deliver central heating oil all round the Truro district in the 1950s and '60s.

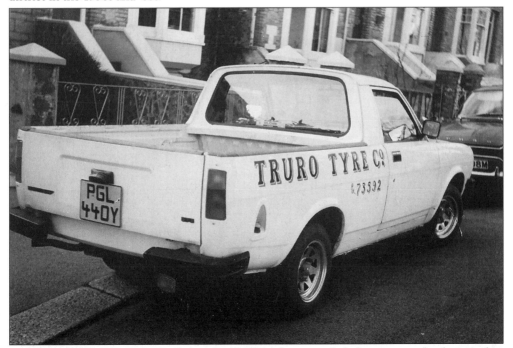

A VANISHED COMPANY. An early 1980s pick-up truck belonging to the late Arthur Mitchell, who owned Truro Tyre Company. He ran his business from Carvedras in part of the building which was once the smelting works.

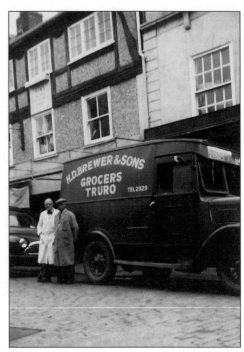

Left: AN OLD TRICYCLE in the early 1920s. This was used as an entry for the carnival. The picture was taken in the yard of Courts Garage in Kenwyn Street which is now Acorn Garage. For many years that garage housed a Buick.

Right: A POST-WAR DELIVERY VAN. Mr Fred Brewer the proprietor is wearing the white coat and with him is Bill Hodge the driver. The van is parked outside their premises at No.6 King Street.

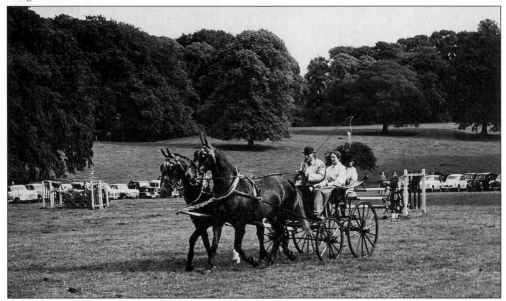

CARRIAGE DRIVING. This is a peaceful scene at Trewithen in the early 1960s, where a beautiful pair of horses give a glimpse of an elegant past. Even the cars parked around the ground reflect a more graceful age.

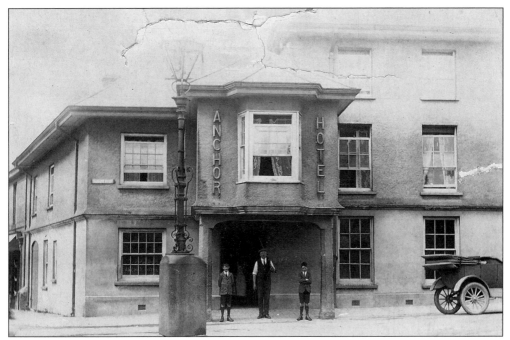

A VINTAGE CAR sits outside The Anchor Hotel, Station Road, just after the Great War. Young Truronian Jack Parnell is on the right nearest the car, but the whereabouts of the Anchor Hotel is unknown.

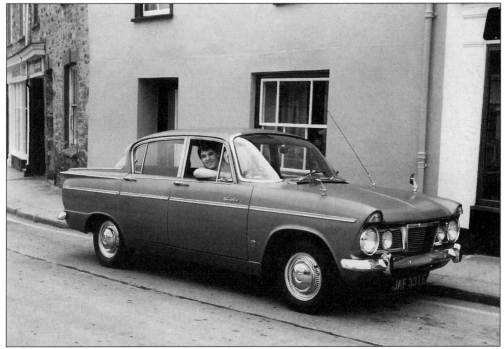

A 1967 HUMBER SCEPTRE. This elegant car is parked outside No.23 Kenwyn Street, the house of the owner Mr Dennis Mitchell. Although Mr Mitchell had no garage for his car, he did have something more unusual, a stable block at the rear of his premises.

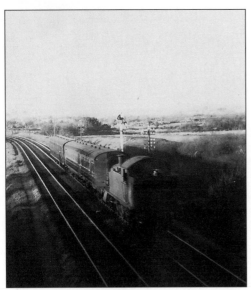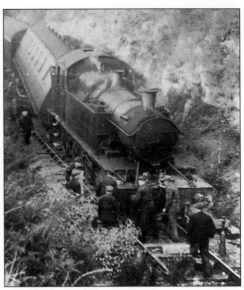

Left: ON THE RAILS. A steam train puffs along the Falmouth to Truro line in the 1950s, approaching Truro.
Right: OFF THE RAILS. Before the diesel engines took over completely, one of the last steam trains unfortunately derailed just outside Truro.

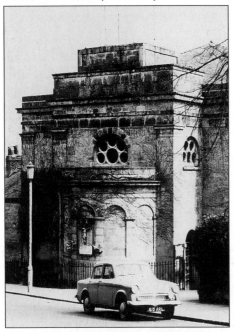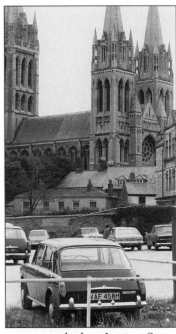

Left: A HILLMAN MINX. During the late 1950s a solitary car is parked in Lemon Street outside St John's church. The church architect was the deaf mute Philip Sambell. The street was not yet festooned with double yellow lines and a person could park with impunity.
Right: A CAR PARK. By the 1970s car parks had sprouted up all over the town and yellow lines appeared everywhere in an attempt to make motorists use the car parks. In spite of the fact that the charge for up to four hours was just one shilling (five pence today) there are plenty of spaces available.

Nine

Out and About
Around the District

Truro is surrounded by some beautiful countryside and lovely little villages so a taste of them is described in this chapter. To cover the area fully would need another book! After a trip around the district we come back up the river to finish in Truro where we began.

CALENICK a beautiful little village which lies at the foot of the Old Falmouth Road. The clock tower is part of the house where the manager of the old smelting works lived. The works closed in 1891.

THE ANDREW SISTERS, Evelyn and Ann Bath, seen outside their home at The Ship Inn, St Clement, at the turn of the century.

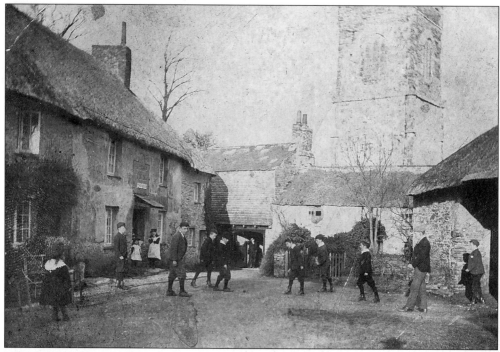

THE SHIP INN in a village scene taken outside the church at St Clement early this century. The landlord of the Ship was Thomas Andrew, father of the little girls in the doorway and the last landlord of the pub.

114

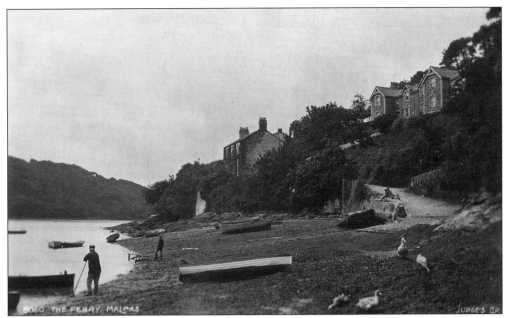

MALPAS, *c.* 1900. A ferry to and from St Michael Penkivell operated from this slipway.

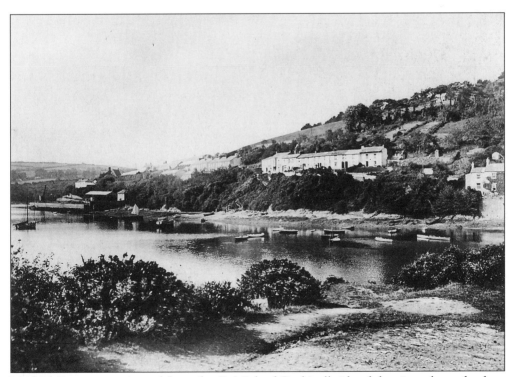

MALPAS in a scene viewed from the St Michael Penkivell side of the river above the ferry landing slipway.

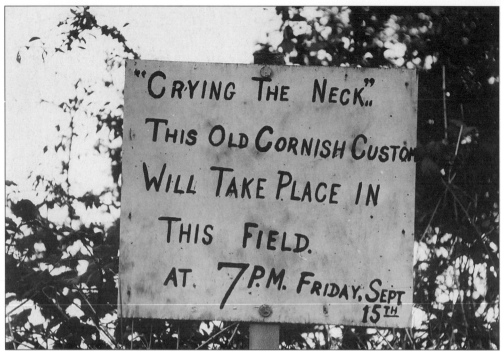

CRYING-THE-NECK, 1961. The field referred to was on the land of Mr Hosking at Fentongollan.

THE NECK. In 1961 Truro Old Cornwall Society held the Crying-the-Neck ceremony at Fentongollan. The last cut of the harvest is made and the farmer, F.C. Hosking Esquire, holds the neck aloft. He calls out three times, "We 'ave 'en." Back comes the reply, three times, "What 'ave 'e?" "A neck, a neck, a neck!" calls the farmer.

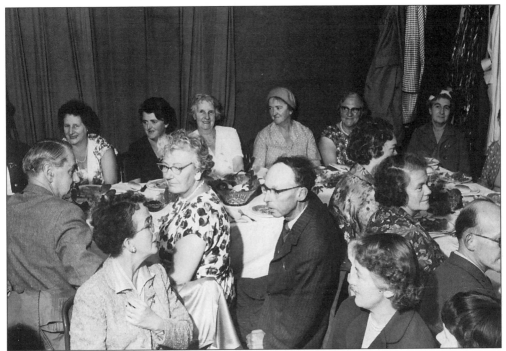

HARVEST SUPPER, 1961. After the Crying-the-Neck comes the harvest supper at St Michael Penkivell Village Hall. While waiting to be served Mr Arthur Lyne chats to Mrs Keigwin-Ledbury.

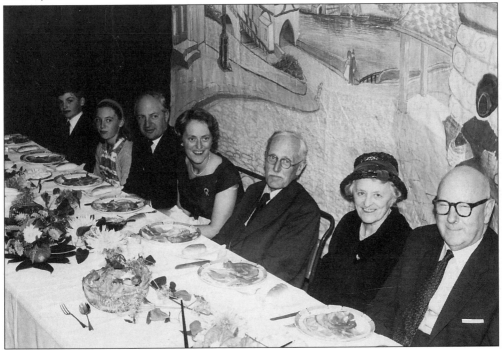

SUPPER IS SERVED. John Rosewarne, who was president of Truro Old Cornwall Society in 1961 is seated beside Lady Falmouth with Lord Falmouth on her right.

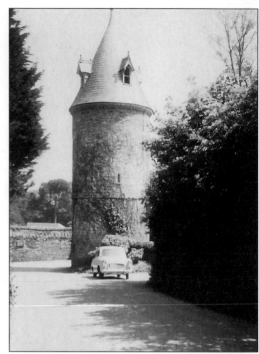

Left: THE IGNIOC STONE situated in the vicarage garden at St Clement, is examined by the Revd O'Flynn and a visiting professor (McAllister?). The stone once served as a gatepost to a field and is thought to be from the fifth century. The inscription reads: 'Isniocus vitalis filius torrici', according to *History of Cornwall* by J.H. Couch (third edition 1893).

Right: TRELISSICK. The water tower at Trelissick is much in demand these days as a holiday home rented out by The National Trust.

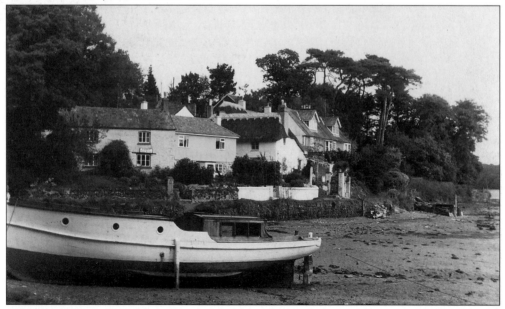

ST CLEMENT, *c.* 1960. The village viewed from the creek showing the post office behind the postbox in the wall.

118

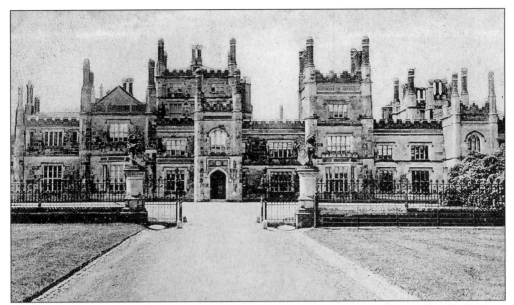

TREGOTHNAN. The north front of Tregothnan, home of Viscount Falmouth, which has a commanding view of the beautiful River Fal. From the viewing point at Trelissick Gardens, Tregothnan can be glimpsed across the river through the trees.

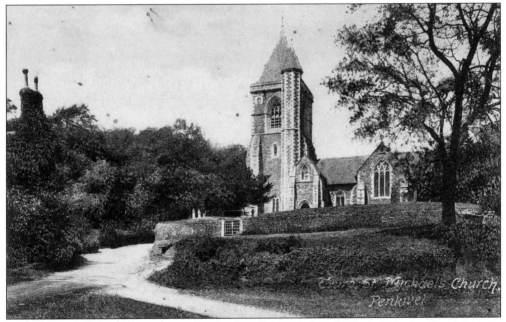

ST MICHAEL PENKIVELL. St Michael's church, restored in 1865 contains many monuments pertaining to the Boscawen family. Apparently the old church was endowed before the conquest.

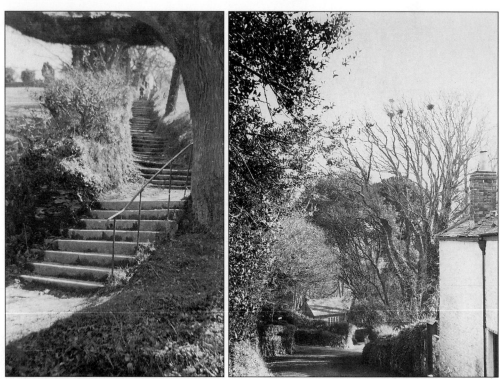

Left: FORTY STEPS. This picture, showing a view of the steps from Featherbeds Lane was taken on Good Friday, 1963. The steps lead up to Kenwyn churchyard.
Right: KENWYN, c.1960. The road winds down to Kenwyn parish church where the room over the lychgate can be seen.

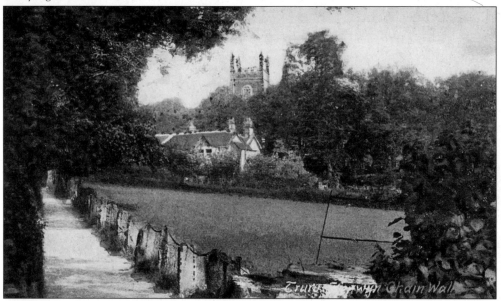

CHAINWALK. A favourite walk of Truronians for many years, the chainwalk led from Kenwyn Hill to the church. Although still there, the walk has changed greatly today with the arrival of a housing estate to replace the green fields.

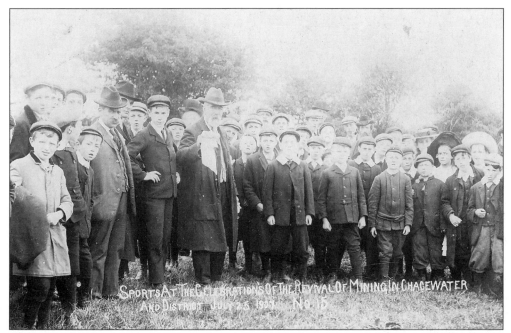

CHACEWATER on the occasion of sports at the celebrations of the revival of mining in Chacewater and district on 25 July 1907. Unfortunately the author cannot name anyone in the photograph.

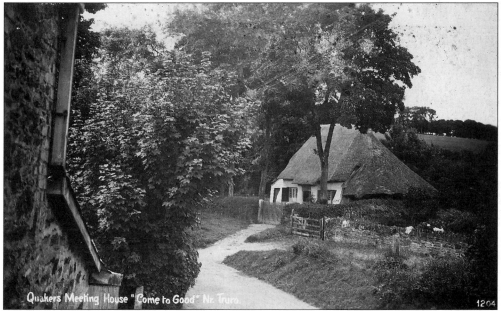

COME TO GOOD. 'Since 1710 this building has been loved and cherished by Cornish Friends' states the guide-book on sale in the meeting house. The present 'new' porch was added in 1967 with the children's room and kitchen beyond. At the near end of the building is the undercover tethering for horses.

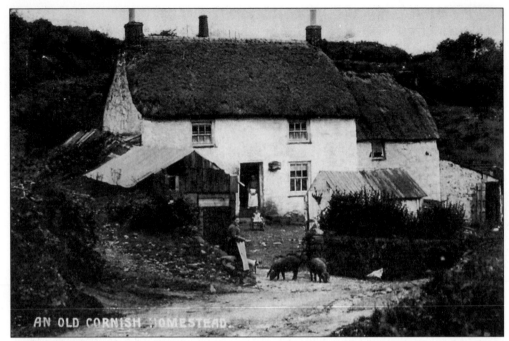

A THATCHED COTTAGE. Ninety years ago this would have been a common sight around the Truro district but today it is a rarity.

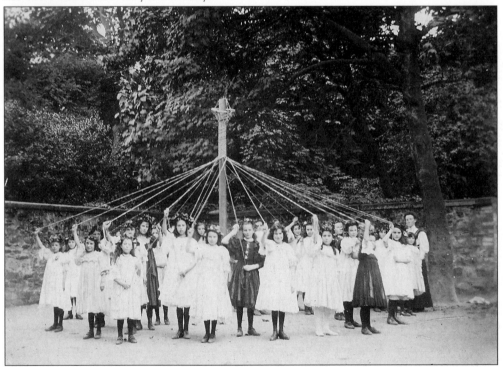

A MAYPOLE DANCE. This card was sent by a little girl called Edith to her aunt in the early 1900s, asking whether her aunt at Newbridge could spot her in the picture. She also asked her to 'bring in a fowl for mother on Saturday'.

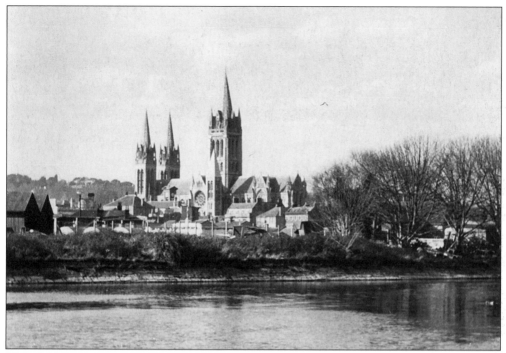

THE CATHEDRAL, 1950. This is an unusual view of the city taken from a boat in the river as it sailed towards Turnaware Bar and an afternoon picnic.

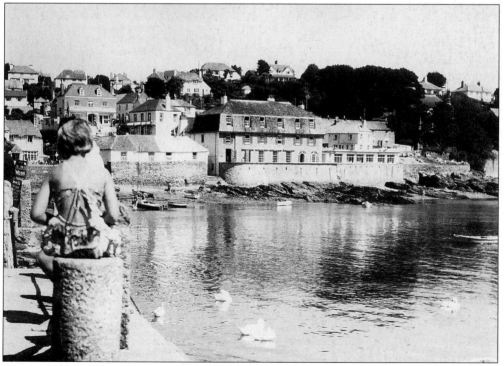

ST MAWES, 1958. A little girl sits on a capstan and watches the swans glide along the waterfront of a peaceful St Mawes.

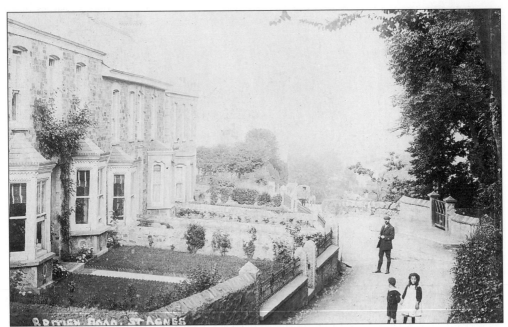

ST AGNES, 1908. A young lady in her white pinafore watches the cameraman as he captures a view of British Road, St Agnes.

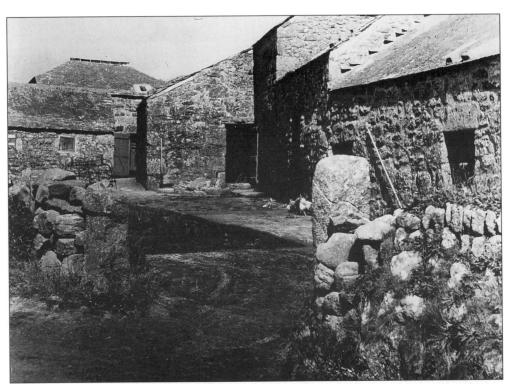

A FARMYARD during the 1950s. This photograph shows an old-fashioned farmyard with chickens running freely, which is believed to be in the Idless area.

QUENCHWELL. This is one of the numerous Methodist chapels scattered about the district. Quenchwell Bible Christian Memorial chapel is still in use today.

PORT HOLLAND. The Methodist church here is sheltered by cliffs and close to the sea.

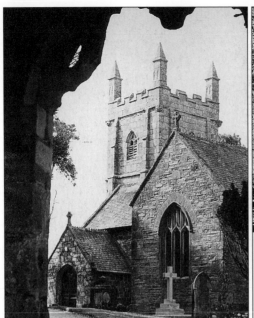 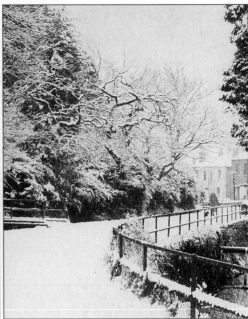

Left: PERRANZABULOE PARISH CHURCH. The present church stands some two miles inland from the original 'lost' church in the sand dunes above Perranporth. In 1804 this church was built after two attempts to rebuild in the dunes resulted in the structures being overwhelmed by sand. St Piran is the patron saint of Cornish miners and on St Piran's day, on 5 March, a pilgrimage is made to the 'lost' church site and a service held.

Right: THE LEATS, 1963. This is a very unusual scene with a thick carpet of snow covering The Leats. An intrepid lady walks her dog through the pristine snow alongside the river.

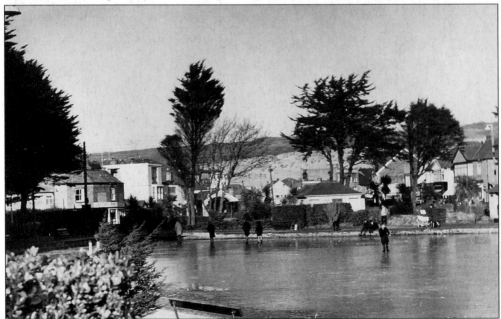

THE BIG FREEZE. The lake at Perranporth, froze over in 1963, which tempted young skaters onto the ice and provided a short-cut to the village shops.

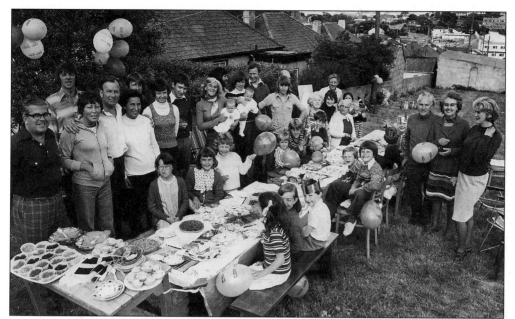

A STREET PARTY. The residents of Highertown celebrate the Queen's silver jubilee in 1977 by holding a street party in Kestle Drive. First and fifth on the left are Derek and Myra Hewitt. For many years Derek was chief cashier at Lloyds Bank in Truro, but in the 1990s emigrated to Australia after retiring. Second and third from the right are Byryn and Margaret Mitchell. The New County Hall, where they both worked, can be seen in the extreme top right of the picture.

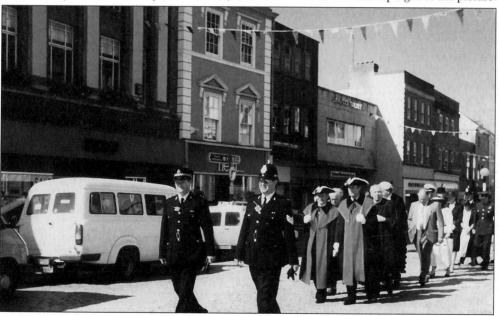

THE RED JUDGE. Not a very old picture but a very old tradition as the Red Judge parades to the cathedral before the opening of the Crown Court. This used to occur in the county town of Bodmin but was transferred to Truro with the building of the new Crown Court on Castle Hill. Inspector Peter 'Jack' Parnell and Sergeant Peter 'Dudley' Williams lead the parade back from the dedication service in the cathedral to the town hall.

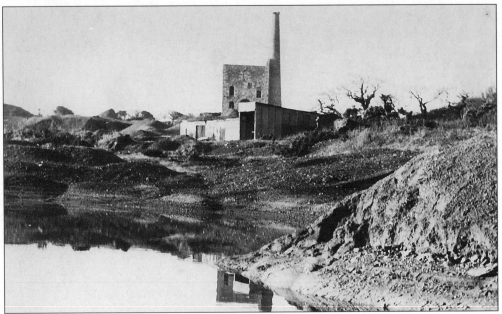

THE MINING HERITAGE with Chiverton Mine photographed in 1959. Once a symbol of Cornish prosperity and industry it is now just another derelict site of scarred landscape, yet this scene personifies the mystery and atmosphere of Cornwall.

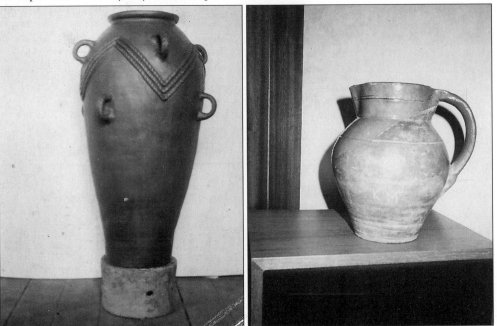

Left: LAKES POTTERY. A very fine coil-built pot, four foot high was made in the 1950s by Mike Edwards and Bill Lake for an exhibition.

Right: EVERY PITCHER TELLS A STORY. In the early 1940s, Kenneth Mitchell, an apprentice at Lake's Pottery, made this jug, putting his initials on the side for all to see. This is one of the few pieces of Lake's pottery remaining in Truro as most of it was made for export. Ironically it is found all over the world but is very rare in Truro.